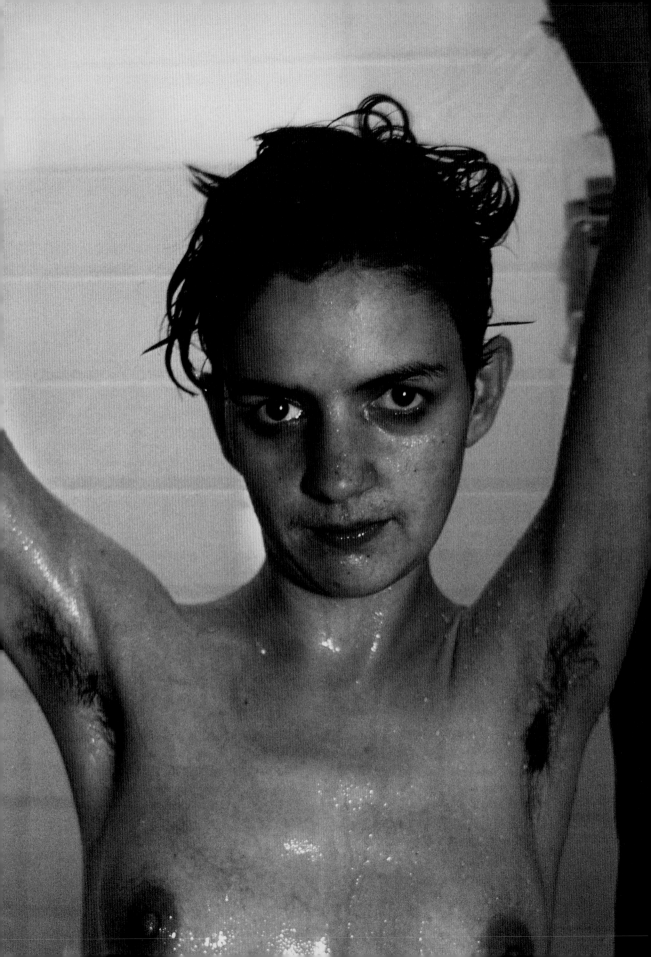

Views from Abroad

European Perspectives on American Art 3

American Realities

Nicholas Serota, Sandy Nairne & Adam D. Weinberg
with essays by
Andrew Brighton & Peter Wollen

Whitney Museum of American Art, New York

Distributed by Harry N. Abrams Inc., New York

Whitney Museum of American Art
July 10 – October 5, 1997

Research for the exhibition and publication was supported by
income from an endowment established by Henry and Elaine
Kaufman, The Lauder Foundation, Mrs. William A. Marsteller,
The Andrew W. Mellon Foundation, Mrs. Donald A. Petrie,
Primerica Foundation, Samuel and May Rudin Foundation,
Inc., The Simon Foundation, and Nancy Brown Wellin.

Library of Congress Cataloging-in-Publication Data
Weinberg, Adam D.
N6512.W39 1995
709'.73'0747471 – dc20
95-16525 CIP

ISBN 0-87427-113-4 (third volume) (Whitney)
ISBN 0-8109-6826-6 (Abrams)

Front and back covers:
top: Roy Lichtenstein, *Whaam!*, 1963 (detail)
Acrylic on canvas, 68 x 160 (172.7 x 406.4). Tate Gallery,
London; bottom: Installation, "A Passion for Pictures:
Selections from the Charles H. Carpenter, Jr., Collection
and Selections from the Charles Simon Collection," 1997,
Whitney Museum of American Art

Frontispiece: Nan Goldin, *Siobhan in the Shower*, 1991 (detail)

Contents

6 Director's Foreword
David A. Ross

8 Preface and Acknowledgments
Nicholas Serota, Sandy Nairne, and Adam D. Weinberg

10 Introduction
Nicholas Serota

13 Modernities and Realities
Peter Wollen

21 The Real Whitney: The Tradition of Diversity
Adam D. Weinberg

35 "American Type Painting"
Sandy Nairne

99 Clement Greenberg, Andrew Wyeth, and Serious Art
Andrew Brighton

106 Works in the Exhibition

Director's Foreword

We are pleased and honored to present the third in the "Views from Abroad" series of exhibitions, designed to provide fresh and illuminating European perspectives on American art. Over the past two years, three European museum directors and their curatorial colleagues have produced extraordinary installations of twentieth-century American art, distinct not only from one another, but from collection-based exhibitions organized by the Whitney Museum's own curatorial staff. "Views 3," organized by Nicholas Serota, director, and Sandy Nairne, director of public and regional services, of the Tate Gallery in London, presents masterpieces from the Whitney Museum's Permanent Collection chosen to represent a particular British perspective on American art of this century.

In an era characterized by a globalized culture industry, the very idea of a "view from abroad" registers as a bit old-fashioned. The physical and cultural distance implied in the notion of "abroad" seems positively quaint in the age of Internet and jet travel. Moreover, the series title itself sounds curiously like a work of Henry James-era romantic fiction. Can the view from abroad magically reveal some essential character of American art without demanding a substantial suspension of disbelief? And all this is complicated by the fact that any purported perspective on the nature of a national culture contradicts the now widely held opinion that there is in fact no such thing as an essential national character, and that our attempts to make such characterizations are founded on prejudices and preconceptions.

These concerns aside, the concept of a foreign perspective still captures the imagination, especially within the American art world. As brash and confident as contemporary American culture may seem, the insecurity born of our relative youth still runs deep. As we have learned through the process of organizing these exhibitions, very few European museums have a representative collection of American twentieth-century masterworks because they did not collect American art until after World War II. There are, for instance, no paintings by John Sloan or Stuart Davis in any European museum collection, no Georgia O'Keeffes. With the exception of one painting in a Spanish museum, there are no Edward Hoppers to be found in public collections on the Continent. Yet our European colleagues can't be blamed for this late recognition of American art. After all, before the opening of the Whitney in 1931, few American art museums took the work of American modernists seriously.

Perhaps the most fascinating revelation of these three exhibitions has been that American art, especially contemporary American art, seems to function as a tabula rasa upon which assumptions about the aesthetic qualities of American society are laid out for consideration and debate. It is also clear from the various organizing principles and selection processes of the three European museum directors, combined with the

geographical shifts in exhibition context, that ostensibly fixed characteristics of twentieth-century American art are more culturally specific than we would have thought.

In this exhibition, Nicholas Serota and Sandy Nairne examine "American Realities," the role and evolution of the figure and other manifestations of representational imagery in twentieth-century American painting. By crossing the generational gap between pre- and postwar American painting, Serota and Nairne isolate what they consider a hallmark of both the Whitney's collection and of American art itself.

As he has throughout this series, Adam D. Weinberg, the Whitney Museum's curator of the Permanent Collection, has worked closely with our distinguished colleagues from abroad. This project, which evolved from an idea first proposed by Weinberg, has proved the importance of continually renewing our understanding of our collection. The enormous popular response to the series both here and abroad has also made it clear that exhibitions of the Permanent Collection can provide exciting opportunities to delight in the great works of art which literally define this Museum.

David A. Ross
Director
Whitney Museum of American Art

Preface and Acknowledgments

"American Realities" is the third in a series of exhibitions that explore European perceptions of twentieth-century American art. The present exhibition considers the possibility that American art, even such manifestations as Abstract Expressionism and Minimalism, is fundamentally concerned with notions of reality. The question of what realism is has been crucial throughout the century: is it something extrapolated from the world—a figure, a landscape, an object—something internal to the artist—a mental or emotional state—or the intrinsic, ontological character of the work of art itself.

The essays in this catalogue offer a range of views on the historical position of American realism, but they all concur that the role and nature of realism and its relative significance to American art need to be reassessed. These essays provide a starting point for a series of revisionist views which question the premise that the triumph of Abstract Expressionism was the most significant, determinative event in twentieth-century American art. The curators would like to thank contributing authors Peter Wollen, professor of film and television at UCLA, and Andrew Brighton of the Tate Gallery, whose essays greatly enrich the thesis of the exhibition.

We greatly appreciate the efforts of Bruce Mau and Kevin Sugden, who creatively adapted the form of the exhibition catalogue to the structure of the exhibition. Janet Cross, the architect of the exhibition, has done an extraordinary job of designing a space which articulates the vision of the curators.

We would also like to acknowledge the Whitney Museum staff for its support in realizing the exhibition and catalogue. First and foremost, we are grateful to David A.

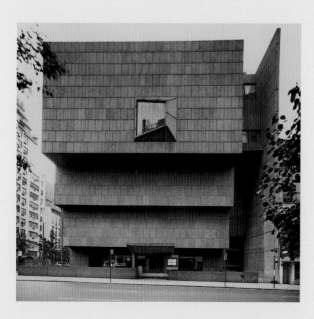

Marcel Breuer, architect
Whitney Museum of American Art,
facade, 1966, New York

Ross, director, and Willard Holmes, chief operating officer, for recognizing the significance of a collaboration between two major collections of national art. Mary E. DelMonico, Nerissa Dominguez, Sheila Schwartz, Ann Sass, Sarah Newman, and Brian Hodge of the Publications Department were tireless in their efforts to produce and edit the catalogue. Anita Duquette assured the superior quality and availability of the images reproduced. Nancy McGary, Barbi Spieler, and Ellin Burke handled the registration and conservation of the works. Christy Putnam capably took charge of the budget and coordination of the installation, and Lana Hum ably supervised the construction of the galleries. We are especially appreciative of the efforts of Naomi Urabe, senior curatorial assistant, who coordinated the exhibition on a daily basis, assuring that the joint tasks of the Whitney and the Tate were carried out with optimum efficiency.

We are also indebted to the staff of the Tate Gallery: to Ruth Rattenbury, head of exhibitions; Laura Down and Alison Blease in public and regional services; Sue Liddell and Catherine Clement in the registrar's department, and Suzanne Freeman in the director's office.

Nicholas Serota, Director, Tate Gallery
Sandy Nairne, Director of Public and Regional Services, Tate Gallery
Adam D. Weinberg, Curator, Permanent Collection, Whitney Museum of American Art

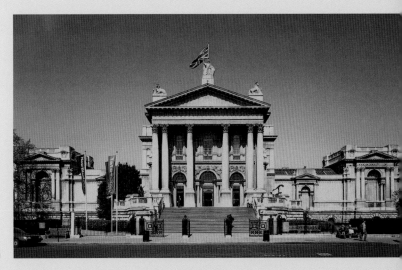

Sidney Smith, architect
Tate Gallery
front elevation, 1897, London

Introduction

When visiting major museums, one can no longer assume that favorite works will be found in the same place. For more and more art museums, particularly those showing twentieth-century and contemporary material, the ideal of a permanent, and canonical, arrangement of works no longer makes sense, given the increasing knowledge and sophistication of the museum-going public. For the Tate Gallery, pressure to show a wider range of the collection and different aspects of history was the catalyst for the "New Displays" program which commenced in 1990. Each year, some six to seven hundred works are presented in new thematic, period, or monographic groupings. With such a change comes the final separation between the concept of a collection as a fixed inventory of works of art and collection displays as events in time, marked as much as any loan exhibition by the particularities of their curatorial choices and the inflections of meaning brought about by specific juxtapositions and combinations.

The "Views from Abroad" series conceived by the Whitney Museum takes transformation in the museum a stage further by emphasizing not just the nature of curatorial choice but the worldwide discourse which informs it. In this series, involving three successive European museums, the curatorial process is doubly emphasized by the presumption that foreign curators will know less than their American counterparts about the works and that they will be reluctant to accept the conventional history of American art.

We approached the project with a strong sense of the Tate Gallery's own place in the history of the presentation of American art in Britain. The Tate, like the Stedelijk in Amsterdam, mounted the exhibition of new American painters organized by New York's Museum of Modern Art and presented to such acclaim in Europe in 1958–59. The exhibition played a small but influential part in transforming the European assessment of American art from provincial and peripheral to revolutionary, highly influential, and central to developments worldwide. But this perception clearly obscured the existence of an earlier, prewar cosmopolitanism, which manifested different forms of radical modern figuration. It is now apparent that, in the long view, there may be connections between, say, John Sloan and Eric Fischl or Nan Goldin that would be worth special exploration. This led us on a track of the "real" for "Views from Abroad." Admittedly using the term in an elastic way, we have explored the idea of bringing particular, sometimes neglected, works to critical attention and reviving a broader view of modernism which does not regard an interest in the figure as being, by definition, antimodern.

We have brought one work from the Tate to hang as part of the exhibition. It is Roy Lichtenstein's *Whaam!* There are many British artists, including Walter

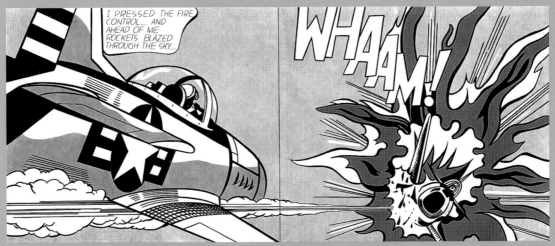

Roy Lichtenstein **Whaam!**, 1963. Tate Gallery, London

Sickert, Stanley Spencer, or Richard Hamilton, whose works could be juxtaposed with great benefit to those of American counterparts. But given the inevitable limitations of a single floor, it seemed more effective to stay with American works alone. *Whaam!*, as an icon of postwar critical realism, humorous and political, stands here as a linchpin for the many forms of the "real" in the exhibition and as a metaphor for the force with which American art hit Europe in the second half of this century.

Nicholas Serota
Director
Tate Gallery

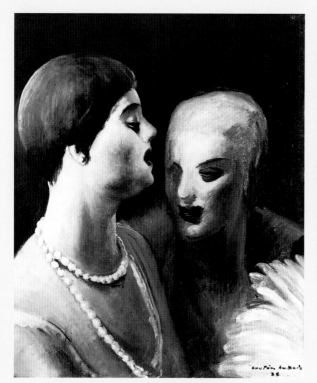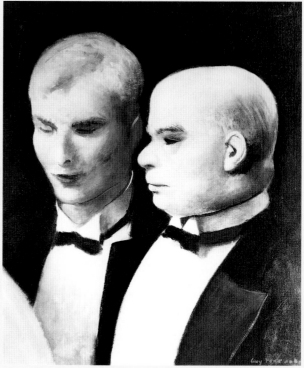

Guy Pène du Bois
Left: **Mother and Daughter**, 1928
Right: **Father and Son**, 1929

Facing page:
Louis Schanker
The Ten Whitney Dissenters, 1938
Color woodcut, $16\frac{7}{8}$ x $12\frac{1}{8}$ (42.9 x 30.8)
Whitney Museum of American Art, New York;
Purchase, with funds from Louis Schanker 78.78

Modernities and Realities
Peter Wollen

The triumph of modernism in the visual arts did not entail the end of realism, even though the rhetoric of modernism often seemed to suggest that realism's demise could be the only logical outcome. In fact, realism—taken in the broad sense—has flourished throughout the twentieth century, both in Europe and in the United States, the heartlands of modernity. Its survival in the heyday of modernism has certainly depended on its somewhat slippery ability to present itself as something else—often enough, as a variant of modernism, as it did in the case of Neue Sachlichkeit or Mexican muralism or Surrealism or Pop Art. In fact, I would argue, the more art moved toward abstraction and the more artists tried to avoid the representation of recognizable objects, the more realism clung on and came back knocking at the door—as an inevitable return of the repressed.

There is no doubt that art in the twentieth century has been concerned to find new ways of representing the world. However, one of the constant assumptions of modernism has been that our mode of perceiving the world has changed with the world itself—that the experience of living in a great city, of traveling at unprecedented speed, of encountering constant change and contrast, of being bombarded with man-made images on billboards and on TV sets, that all the myriad ways in which modernity has been articulated visually have made it necessary for artists to represent the world in new, unprecedented, and initially disorienting forms. If we take "realism" simply to mean a traditional vision of the world, then realism and modernism will be incompatible. But if we take "realism" to include the creation of new modes of representation to grasp the new visual reality in which we live, then much of modernism simply becomes a new mode of realism, one more appropriate to the twentieth century.

The standard history of American modernism, looked at schematically, begins with the Stieglitz circle, reaches its first breakthrough with the Armory Show in 1913, which is followed by Duchamp's impact on the Arensberg circle. Then it peaks prematurely in the 1920s with the work of a fresh cohort of artists influenced by Cubism and the machine aesthetic, before going into recession during the 1930s (seen as a period of realist reaction). For a while, nothing much happens until the appearance of such groups as the Whitney Ten (1935) and American Abstract Artists (1936). Then, during World War II, the whole climate changes completely, due in part to the impact of Surrealist abstraction; soon afterwards, Abstract Expressionism is launched. Meanwhile, Rauschenberg and

Johns appear on the scene. Then, during the sixties, Pop Art contends for supremacy with Color Field painting, Minimalism, Serialism, and a number of other trends. Eventually, Conceptual Art clears the field for the rise of the new genres which dominate the American art world today — installation, performance, photography, video, etc. — a process punctuated by recurrent revivals of both figurative and abstract painting and an increasingly reflexive postmodernism.

John Sloan
The Hawk (Yolande in Large Hat), 1910

Of course, this "history" is very crude, but it has a certain logic, founded on the idea that the destiny of American modernism was to make a clean break with a persistent, indigenous attachment to realism, in order to overtake and surpass an exhausted French modernism. Once this was achieved, realism could be readmitted into the modernist canon in such intrinsically American forms as Pop Art and Photo-Realism, or simply as the work of gifted artists, ranging from Leon Golub to Cindy Sherman. What is immediately striking is the inconsistency inherent in the refusal to acknowledge the modernity of realism before Pollock, while happily admitting it afterwards. In this context, it is provoking to see how Edward Hopper, for example, was successfully rehabilitated as a precursor of this new American "postrealism," whereas the early Ashcan School painters and then the thirties social protest painters and Magic Realists were not, even though they might easily be viewed as precursors of, respectively, Leon Golub and Cindy Sherman.

Let's begin by looking at Hopper. Hopper was a pupil of Robert Henri, the acknowledged leader of The Eight (who were not dubbed the Ashcan School until 1934). The group's landmark exhibition at the Macbeth Galleries in 1908 drew a sharp dividing line between a journalistic and an academic version of realism. I say "journalistic" advisedly. The core of The Eight came, as did Henri, from Philadelphia, where they had begun as newspaper illustrators for the Philadelphia press. William Glackens worked for the *Record*, George Luks and Everett Shinn worked for the *Press*, John Sloan for the *Inquirer*. The work these men did was threatened by the advent of newspaper photography, and they wisely reoriented themselves as professional artists, under Henri's tutelage. To launch themselves, they joined forces with three other painters, Arthur B. Davies, Ernest Lawson, and Maurice Prendergast, who had been influenced by "advanced" French painting — Symbolism, Impressionism, Post-Impressionism.

The Philadelphia group carried their reporters' habits and impulses into the New York

art world. They went out on the beat, so to speak, to sketch moments of city life, which they then worked up, following the guidelines learned from Henri, into finished oil paintings. In particular, they often painted subjects that were considered sordid and, as a result, were under constant attack from guardians of morals and proponents of censorship. In a sense, they were the Mapplethorpes and Goldins of their day. The Macbeth Galleries exhibition launched them in the New York art world and their influence proved long-lasting, mainly through Henri's continued activity as a teacher. Among his students were Edward Hopper, George Bellows, Stuart Davis, Guy Pène du Bois, and Rockwell Kent, as well as Morgan Russell and Patrick Henry Bruce, who later gravitated toward abstraction.

This second generation remained fascinated with everyday life, particularly city life, but frequently with a more modernist inflection, as was the case with Hopper, who listed himself as an "illustrator" in the New York city directory while he learned how to manipulate converging lines and areas of color to pinpoint his human figures. Stuart Davis and Rockwell Kent also became dominant figures in the thirties, when they each played an important role in the artists' politics of the day. I don't think there is any doubt that Davis was the most ambitious member of this group, the only one who eventually succeeded in fusing the Ashcan School subjects drawn from city life and popular culture with a personal post-Cubist idiom. In fact, Davis ended up, in the 1950s, as a premature Pop artist. Like Bellows, his career was grounded in his early illustrations for *The Masses* and *Harper's Weekly* (for which Sloan and Shinn also worked) back in 1913, but unlike Bellows he was deflected away from Ashcan realism by his experience of the Armory Show.

Reginald Marsh studied with Sloan and Luks at the Art Students League in the early 1920s, but was most influenced by another teacher, Kenneth Hayes Miller, who was more concerned with the rendering of volume in a shallow space. Philip Evergood, a leading Social Realist painter of the thirties (though American, he was educated in England at Eton and Cambridge), also studied under Luks on his return to America in 1923. Among other painters who emerged in the thirties, Isabel Bishop studied with Miller and Guy Pène du Bois, Moses Soyer was taught by both Henri and Bellows, and his twin brother, Raphael Soyer, by Pène du Bois. Thus the legacy of The Eight passed directly into the thirties, where it became a basic constituent of the social protest painting which emerged in the period of the New Deal and the Popular Front.

The other major ingredient in thirties Social Realist painting was the legacy of Mexican muralism. It is often forgotten how important Mexico was to American artists in the interwar period. Due largely to the efforts of José Clemente Orozco, Diego Rivera, and David Alfaro Siqueiros, Mexican painting became a model of how to combine modernism with social protest realism. And the Mexican artists also worked in the sphere of journalism, providing illustrations for the Communist *El Machete* just as American artists did for *The Masses* and *The New Masses*. Moreover, Mexican muralism was the inspiration for the state-sponsored WPA mural program which formed the centerpiece of New Deal

policy for the visual arts. Finally, all three of *los tres grandes* worked for a considerable time in the United States and produced major work both on the West Coast and in the Northeast, including New York. Rivera's prestige was such that, despite his revolutionary Marxism, he worked successively for the San Francisco Stock Exchange Club, Edsel Ford, and finally Nelson Rockefeller.

Primarily, the Mexican muralists influenced the Social Realist artists—leading disciples were the artists of the Coit Tower murals in San Francisco or Ben Shahn in New York. Yet, ultimately, the most successful disciples of the Mexicans were two artists and old friends from Los Angeles—Philip Guston and Jackson Pollock, who eventually turned to abstraction. During the thirties, Guston was an extremely successful figurative painter— his 1937–38 *Bombardment* is a masterpiece of protest art. Guston painted a mural in Mexico, with his friend Reuben Kadish, under Siqueiros' sponsorship, and Pollock worked in Siqueiros' New York studio in the mid-1930s. Pollock also studied under Thomas Hart Benton, the nearest North American equivalent to the Mexicans, who began as an illustrator of Leo Huberman's *We The People*, but moved from the left toward the right as the thirties progressed, leaving New York for his native Kansas in 1935 and becoming a leader of the Regionalist school, or American Scene painters. Pollock later spoke of his turn to abstraction as a reaction against Benton's overpowering influence on him in earlier years, which evoked a necessary aesthetic counterforce.

Mexico, however, also attracted artists who had nothing to do with muralism or social protest, including both Marsden Hartley and Milton Avery, who lived there for a time during the early thirties and mid-forties, respectively. Hartley began his career in the Stieglitz circle, together with Dove and O'Keeffe, and like them eventually turned away from New York. His Mexican paintings are visionary landscapes, painted in bright, saturated colors, full of the "soil-and-spirit" ethos which Stieglitz came to propagate. Avery also responded to Mexico as a colorist with a series of paintings in a vivid and schematized neo-Fauvist style. For these artists, Mexico (like Taos for O'Keeffe) was a way of escaping not simply New York, but the Depression and the stress and strain of art world politics. In their work, Mexico is not the site of politics and revolution; rather, it is an overwhelming spectacle of color, reminiscent, in its way, of Matisse's vision of Morocco.

Avery had been a friend of Mark Rothko since the end of the twenties; they had even exhibited together. Avery, it now seems, passed on his preoccupation with color to Rothko. Around the same time, Rothko met Adolph Gottlieb and introduced him to Avery. In 1935, Rothko and Gottlieb were instrumental in founding a group known as The Ten, whose joint exhibitions culminated in 1938 with a show titled "The Ten Whitney Dissenters." In their publicity for the show, they accused the Whitney of supporting the "reputed equivalence of American painting and literal painting" and protested that "the symbol of the silo is in the ascendant at our Whitney Museum of modern American art"—implying that the Whitney had surrendered to the forces of Regionalism, American Scene painting, and

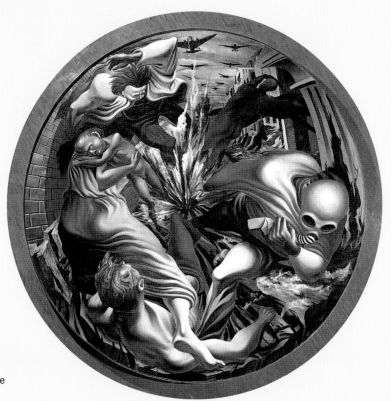

Philip Guston
Bombardment, 1937–38
Oil on wood, 46 (116.8) diameter
Private collection; courtesy McKee
Gallery, New York

a conservative realist pastoralism. Soon Rothko and Gottlieb would join forces with
Surrealist-influenced painters, such as Baziotes, Motherwell, and Pollock, to launch a new
wave of abstraction.

The Whitney Museum was indeed preponderantly realist in its early years. Gertrude
Vanderbilt Whitney had been the main buyer at the Macbeth exhibition of The Eight, and
her protégé, Juliana Force, followed the same line. Force had originally been Gertrude
Whitney's secretary, but, in time, she was appointed first as manager of all the Whitney
art activities (building Gertrude Whitney's collection and running the Whitney Studio
Club, with its own library, billiard table, life class, and program of exhibitions) and then
as director of the new Whitney Museum, which opened in 1931. The Whitney Studio Club
had no explicit policy, but in effect it was a gathering point for the Ashcan painters and
their second-generation students. By the end of the twenties, Mrs. Whitney and Juliana
Force had expanded their purview to include the painters who later formed the core of the
Regionalists — Benton and John Steuart Curry, although they resisted Grant Wood for a
considerable time. Stieglitz's antipathy to the Whitney Studio Club enterprise had left gaps
in Mrs. Whitney's collection, which she filled in by buying work by Stieglitz artists Demuth
and O'Keeffe for the new Whitney Museum. She also splurged on Bellows' *Dempsey and
Firpo*, hanging it on the main staircase for the opening. (It cost her $18,750, the highest
price the Whitney paid for any work until 1960).

Gradually, the Whitney spread beyond the boundaries of the old Club habitués to justify
its role as a museum of American, rather than Greenwich Village art. However, neither

Mrs. Whitney nor Juliana Force ever really adapted to the changes that overwhelmed the New York art world during the thirties. Neither woman had any interest in politics and resented the politicization of art. Conversely, they had little concern with the new European trends—such as purist abstraction or Surrealism—that were beginning to make an impact on artists in New York, largely as a result of Alfred Barr's Museum of Modern Art, which, unlike the Whitney, specialized in modernist art—albeit European rather than American. Battle lines were being drawn on both aesthetic and political grounds as New York embarked on the turbulent period which would finally lead to the triumph of Abstract Expressionism. At this point, the Whitney simply opted out.

It was not till 1945 and 1946 that the Whitney finally showed Rothko for the first time, along with Pollock and Motherwell. By then, Force had made contact with James Johnson Sweeney and come to realize that she had to adapt, if only for the sake of appearances. When abstract art triumphed in the forties and fifties, realism was tarred with the brush of "nativism," "isolationism," and "reaction." As a result of the battle between right and left within the art world, realist painting was associated negatively first with Fascism and then subsequently with Communism, once the latter had lost its appeal following the Great Purge and the Hitler-Stalin pact; the association of realism with Communism then continued into the cold war years. This diagnosis of the political meaning of realism and modernism had a grain of truth, but it by no means told the whole story.

As we look at the history of art in the twentieth century, we can see that abstract artists were not necessarily on the left and realist artists were not necessarily Fascists or Stalinists. Both left and right articulated their points of view in many different ways. Similarly, abstraction could be the medium for inner-directed mysticism as well as for the machine aesthetic, for wild romanticism as well as severe classicism, for utopian radicalism as well as decorative formalism. Realism could be socially critical (as with the Ashcan School) or celebratory (as with Pop Art). America, however, never had an avant-garde in the European sense—a coherent group with both a political and an artistic program, like that of the Constructivists or the Surrealists, until the advent of Conceptual Art in the late sixties, when a true aesthetic revolution coincided with intense politicization of the art world.

In fact, Conceptual Art refigured the concept of artistic practice itself and thus made the whole discussion between realists and abstractionists completely irrelevant. Up until that point, America had a long, zigzagging period of modernization, of learning from France, competing with France, and eventually surpassing France. But if history followed Pollock rather than Bacon, Dubuffet, or CoBrA, it was because Pollock's originality came at the right time politically and economically—a time when American power was being asserted with means far more potent than those which art could ever muster. But even the triumph of American abstraction was not the end of the story. Painters like Philip Guston passed through abstraction only to abandon it again and return to figuration. Alice Neel,

a social protest artist in the thirties who painted the portraits of Communist militants and union organizers, reemerged in the sixties as a "New Realist," painting curator Henry Geldzahler and art star Andy Warhol.

As we look at the art of the twentieth century from the vantage of a new millennium, what will probably strike us is not the end of realism, but the decline of easel painting. Easel painting was undermined by a number of seemingly disparate forces—photography, muralism, Pollock's fateful decision to put his canvas on the floor, the monumentalization of the art work, Warhol's silkscreens, and, above all, by Conceptual Art and the "new genres," including photography. Some of these forces threatened the idea of realism. Others did not. Some, like the acceptance of photography as fine art, equal in status to painting, and the use of slide projectors as tools, have actually promoted a new taste for realism. We should think carefully about the great revolution in the canon that modernism itself ushered in—a revolution that stripped prestige and value from painters like Gérôme and Puvis de Chavannes, Leighton and Moore, Whistler and Sargent. Can we be entirely sure that Gottlieb or Rothko will not be devalued in the same way as the *pompiers*? When the canon changes again, as it surely must, will Juliana Force and the Whitney be vindicated? The process of reevaluation begins with exhibitions such as this.

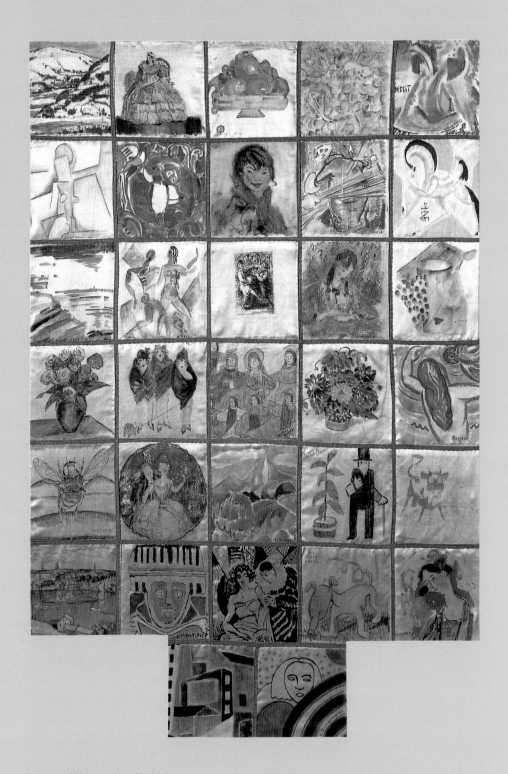

Society of Independent Artists
Collaborative Work, 1922
Mixed media on silk, 32 squares, 45 x 30 (114.3 x 76.2) overall
Whitney Museum of American Art, New York; Lawrence H. Bloedel Bequest 77.1.49

The Real Whitney: The Tradition of Diversity
Adam D. Weinberg

The story of American art, like any other narrative, is determined by the teller. The Whitney Museum of American Art, which has been in existence for just over sixty-five years, has been one of the key narrators of the tale through its catalogues, exhibitions and, perhaps most of all, its collection. Those who have told the story represent several generations of directors and curators. Although their combined narratives seem at times contradictory, and have often been misunderstood, the Whitney's point of view has actually been remarkably consistent.

To many people, the Whitney stands for a commitment to an art of representation and realism; for others, the Museum has stood in defense of abstract art to the detriment of figurative styles; still others seem to believe that the Whitney is devoted only to radical experimentation and the "new."[1] For a long time, however, at least until after World War II when the Museum deaccessioned its nineteenth-century collection, many saw the Whitney as the repository of the historical antecedents of contemporary American art. One has only to read a selection of reviews and articles written over the last decades to realize that many critics believed and continue to believe that the Whitney has a chronic identity crisis or, even worse, that it lacks aesthetic convictions.[2]

The purpose of this essay is not to undertake a psychohistory of the Whitney Museum, but rather to show that these multiple and divergent directions were to a large degree consciously determined even before the Museum's inception; and that the Whitney's actual and perceived artistic diversity was and continues to be its strength. The essay focuses on the evolution of the Museum's artistic philosophy as articulated by its founder and its early directors, particularly as it is revealed through exhibition and publication programs. Understanding the origin of this philosophy is crucial because it continues to bear on the Museum's more recent history.

When the Whitney Museum opened in 1931 it was very proud of the fact that its first three curators—Hermon More, Karl Free, and Edmund Archer—were artists. The Museum, founded by Gertrude Vanderbilt Whitney, herself an artist, believed in the urgent need to support living American artists. Mrs. Whitney's desire to encourage the art of her time and to show "the relation of the artist of today with the life of today"[3] was not merely good-natured philanthropy; nor was it a reflection of her own struggle, as an artist and a woman, to break free of the strictures of turn-of-the-century high society. Her declaration represented a fundamental belief in American art as a key record of the progress of a great and now mature American civilization. In 1931 she wrote, "EVERYONE knows that America has developed a new architecture. It is blazoned before the world.

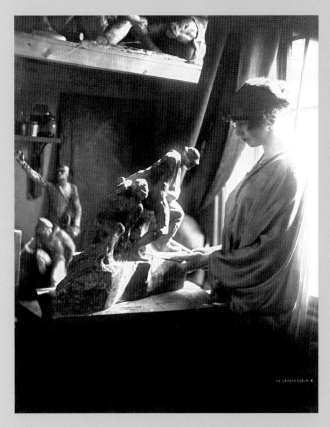

Left: Gertrude Vanderbilt Whitney in her Macdougal Street studio, c.1919.

Right: Noel and Miller, architects Whitney Museum of American Art, entrance, c.1931, 8 West 8th Street, New York

It screeches like our eagle from up in the sky. That we have also evolved a national art of painting and sculpture is less apparent, but no less true."[4] While the nationalist sentiment in this pronouncement also screeches like the eagle that became the symbol of the Whitney Museum, the underlying point is the idea of independence: the independence of American artists to give form to "individual expression" and the independence of the public to "judge [art] for themselves." As Mrs. Whitney further wrote, "It is our steady growth in independence of mind and expression which gives me faith in our future...."[5]

This position was no doubt influenced, and perhaps in large part formed, by Mrs. Whitney's close association with those artists who termed themselves "liberal," "progressive," and "independent." Her support of their exhibitions and publications in the years preceding the establishment of the Museum itself was essential to the survival of American artists. It is well-known history, for example, that Mrs. Whitney, in a dramatic display of encouragement for the revolutionary realist artists known as The Eight, purchased four of the seven works sold from their celebrated 1908 Macbeth Galleries exhibition. These works—Robert Henri's *Laughing Child*, George Luks' *Woman with Goose*, Ernst Lawson's *Winter on the River*, and Everett Shinn's *Revue*—along with the others exhibited, can be viewed as a manifesto of turn-of-the-century realism. Such paintings may have been radical in terms of their subjects, but stylistically they were rather tame, mimicking the painterly bravura of artists from Velázquez to Sargent. Therefore, such works need to

be understood as representing the *idea* of independence, of freedom from the singular, dominant, and anti-democratic direction exemplified by the National Academy of Design.

Embedded in the radical-conservative duality of these works is the origin of the multiple identities of the Whitney Museum. As Avis Berman has pointed out, although Mrs. Whitney was herself a realist sculptor, "her preference for realism was by no means timid or *retardataire* in the America of 1906 and 1907."[6] Mrs. Whitney, together with her assistant, adviser, and confidante Juliana Force, the woman who would become the first director of the Whitney Museum, embraced a liberal attitude. Although not politically inspired, as was the liberalism of some of the Ashcan artists, it was nonetheless deeply felt and a significant motivating force. It was in this spirit that Mrs. Whitney helped found The Friends of Young Artists in 1915, an organization to assist needy American artists, and became the most generous benefactor of the Society of Independent Artists. Common to both organizations was an attitude of openness and the acceptance of a multiplicity of styles. In the Friends exhibitions, typically held in the Whitney Studio Club, "Any entry could be submitted, regardless of aesthetic tendency, as long as it was sincere; the raw, the untried, the unready would get a chance."[7] Although Marcel Duchamp's celebrated *Fountain*, a urinal-turned-art work, was the one piece censored at the momentous Society of Independent Artists exhibition in 1917, the exhibition was "a model of democratic fairness; the hanging [of the more than two thousand works] was done in strictly alphabetical order."[8] The democratic spirit of these organizations affected Mrs. Whitney's thinking and that of Juliana Force and was ultimately reflected in their choice of curators for the new Whitney Museum.

Independence did not simply mean independence from the Academy or from foreign influences. Gertrude Whitney and Juliana Force were committed to laissez-faire individualism,[9] manifested in the importance and trust they and their staff placed in the artist.[10] The artist should lead and the museum should be close behind to support, encourage, and exhibit. The identification of the living artist with the museum seems unremarkable to us today, as contemporary art museums more and more frequently commission art works, realize site-specific installations, and invite artists to use their galleries as studios. Nearly a century ago, however, it was held that the artist was unpredictable and that this unpredictability was to be avoided at all costs. In response to exhibitions like that of The Eight, Sir Caspar Purdon Clark, then director of The Metropolitan Museum of Art, remarked, "There is a state of unrest all over the world in art as in all other things; and I dislike unrest."[11] The Whitney Museum and its antecedents, the Whitney Studio Club (1918–28) and the Whitney Studio Galleries (1928–30), formed largely by and entirely for artists, embraced the spirit of unrest. And it was in the image of the individual, in the person of the artist, that the Museum was modeled.

Perhaps the seeming contradictions, not to mention the complexities of the Whitney Museum's program, reflect a model based on the unpredictable and imperfect "individual," rather than on the concept of an institution with established, ideal standards measured

historically and set apart from individual effort.[12] Thus, the Whitney's first commitment was to exhibit a range of artists representing the best of many aesthetic directions.[13] This commitment, moreover, also implied following an artist's work during many phases of development, even if it sometimes meant supporting minor creations.[14] The Whitney Museum wanted to present an accurate, broad-based view of American art, a position that would also enable the Museum to remain outside the fray of partisan politics and avoid focusing on a single aesthetic orientation.

This philosophy was initially articulated by Hermon More, one of the Museum's first curators and, from 1948 to 1958, its second director. More's statement, one of his few published writings, appeared in the Whitney Museum's first *Catalogue of the Collection* (1931). It became the touchstone of the Museum's policy and was frequently quoted by subsequent directors:

> We shall not attempt to simplify the question by defining in absolute terms the essence of the American spirit and requiring artists to conform to that definition. It would be presumptuous to point out the road upon which art must travel. We look to the artist to lead the way, permitting him the utmost liberty as to the direction in which he shall go. As a museum, we conceive it to be our duty to see that he is not hampered in his progress by lack of sympathy and support. It is not our intention to form a "school," our chief concern is with the individual artist who is working out his destiny in this country, believing that if he is truly expressing himself, his art will inevitably reflect the character of his environment.[15]

However, in part because of Mrs. Whitney's own artistic style as well as her personal connection with both traditional academic artists and progressive realists, the Museum was, at least until the 1960s, thought to have a privileged relationship with the various strains of realist art, from the Ashcan School and Regionalism to Romantic Realism, Social Realism, and Magic Realism.

In a cursory examination of the Whitney's exhibition program, publications, and acquisitions from the founding of the Whitney Studio Club in 1918 until Juliana Force's death in 1948, the record does substantiate an overwhelming emphasis on realist artists. However, artists of the modernist variety were by no means neglected, particularly after the establishment of the Museum and the inauguration of the first Biennial in 1932. The initial collection of the Museum donated by Mrs. Whitney encompassed a significant number of modernist works, among them paintings by Oscar Bluemner, Stuart Davis, Charles Demuth, Preston Dickinson, John Graham, Jan Matulka, Charles Sheeler, and Max Weber. The "First Biennial Exhibition of Contemporary American Painting," established with a $20,000-a-year fund to purchase works from the exhibition, included all the artists mentioned above (except Dickinson) as well as Theodore Roszak, Konrad Kramer, and Georgia O'Keeffe, among others. The Whitney Biennials and Annuals, a regular and major feature of the Museum's exhibition program, played an important role in maintain-

ing a commitment to diversity and to the individual artist's creative evolution.[16]

One could martial much evidence, especially in terms of exhibitions (perhaps less so with acquisitions) to show that the Whitney did not ignore the efforts of modernist and abstract artists, although Mrs. Whitney and Mrs. Force were generally more comfortable with realist art.[17] The larger goal, however, was the attempt by the Museum to maintain the evenhandedness underscored in Hermon More's statement.[18] More's two successors, Lloyd Goodrich (1958–68) and John I.H. Baur (1968–74), pursued and formalized this goal. Despite their predisposition toward realist art, both sought a stylistically balanced program — often a difficult task in the face of intense lobbying by various groups of artists to enlist the Whitney in support of their school. Moreover, as abstract painting became increasingly dominant, a commitment to realism, even progressive realism, became problematic. Nevertheless, both Goodrich and Baur continued to formulate programs based on a "tradition of liberalism in contemporary art."[19]

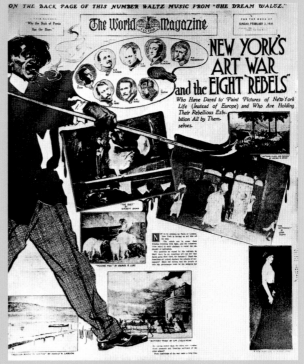

"New York's Art War and the Eight 'Rebels,' cover of *The World Magazine* (New York), February 2, 1908.

Lloyd Goodrich, like other Whitney curators, was trained as an artist. Growing up in New Jersey at the turn of the century, he was a childhood friend of Reginald Marsh, a closeness he maintained throughout his life. Goodrich studied under the realist painter Kenneth Hayes Miller at the Art Students League, along with Yasuo Kuniyoshi, Alexander Brook, and Peggy Bacon. Working as an editor of *The Arts* from 1925 to 1931, he caught the attention of Mrs. Whitney and Mrs. Force. In 1930, he joined the staff of the as yet unopened Whitney Museum as a research curator. Although not trained as a scholar, he was the first Whitney staff member to take a serious interest in the history of American painting. Mrs. Whitney in fact engaged him to produce a series of monographs on American artists, most notably Thomas Eakins, Winslow Homer, and Albert Pinkham Ryder.

Given Goodrich's training, friendships, and art historical predilections, one can easily surmise where his aesthetic sympathies lay. In an early paper entitled "The Problem of Subject Matter and Abstract Esthetics," prepared for a symposium in 1933, Goodrich expounded his somewhat equivocal ideas on realism and abstraction. While the paper attempts to finesse the relationship between "art form" ("the raw material out of which the artist creates something which does not exist in the real world") and representation, it is clear that Goodrich believed that the "subject and its representation have been in the past, and will probably continue to be, the path by which the artist achieves the greatest formal significance."[20] Despite this basic assumption, which he seems to have held to

throughout his career, Goodrich also reaffirmed time and again the democratic individualism posited by Gertrude Vanderbilt Whitney, Juliana Force, and Hermon More, declaring that "ours is a pluralistic art world, expressing the freedom and individualism of an open society."[21] The museum, he cautioned,

> should never forget that the source of art is the artist; it should respect his individuality and not try to impose its own viewpoint on him. It should always welcome the young and the innovator. Recognizing the diversity of contemporary art, it should represent all creative tendencies.... We believe that [virtue] can be found in many different schools and in individuals who belong to no school.... whether they are in the advance guard, the rear guard or the middle guard.... we would rather err on the side of *inclusiveness* [emphasis added] than exclusiveness.[22]

This position contrasted markedly with that of The Museum of Modern Art, which had been founded in 1929, years after the battles of The Eight were fought. MoMA made its significant contributions to the field of American art history by presenting itself as an institutional model that measured art against set standards, standards established by the canon of avant-garde French painting. MoMA considered its American collection to be "a problem," given the Whitney's and Metropolitan Museum's interest in the field. MoMA's acquisition policy in the 1930s was to be "daring and *exclusive*" [emphasis added], since it had "at present neither space nor money nor time to form a representative collection [of American art]. This may be left to the other two institutions." In 1944, James Thrall Soby, then director of MoMA's department of painting and sculpture, maintained that MoMA "does not exist for the direct benefit and patronage of artists."[23] The Whitney's decision to support American artists in all their diversity, including but not restricted to realism, was not made by default, not merely a matter of picking up MoMA's leavings. It was a carefully considered position, occasionally acknowledged by critics. As late as 1960, John Canaday advised: "The Whitney's job is, or should be, to indicate the variety of expression in contemporary American painting.... [T]here is a mass of important and inventive American painting that is neglected because it is not Museum of Modern Art fare, and... the Whitney can establish its own lead by finding this painting and showing it."[24] Despite the hortatory tone, Canaday recognized the Whitney's role and its importance, although he seemed unaware that his advice was reflected in the Whitney's history as well as in its present-day commitment.

Maintaining a position of diversity, or "equalitarianism" (a term frequently used by Goodrich) was not easy. Goodrich and the Whitney were often criticized by both realist and abstract artists. One of the more public and emotional critiques came in a dramatic letter to Goodrich in 1960 following the opening of the Whitney Annual. The letter was signed by twenty-two realist artists who called themselves "a new kind of Friends of the Whitney" (referring to the organization supported by Mrs. Whitney), among them Edward Hopper, Jack Levine, Jacob Lawrence, Robert Gwathmey, Joseph Hirsch, and

Raphael Soyer. In a somewhat less than cordial tone (the letter addressed Goodrich as "Dear Sir," when in fact they all knew him on a first-name basis), they expressed their consternation at the supposed lack of representational art exhibited in the recent Annual. Of the 145 paintings included, "102 were non-objective, 17 abstract and 17 semi-abstract, leaving only 9 paintings in which the image had not receded or disappeared, whereas in former exhibitions the Whitney Museum showed a much larger cross section of style and method in work in progress." The writers approached the Whitney "because more than any other museum in America it has been tied up with fortunes of the American artist, and has exercised a personal warmth and interest in his developmental processes." And they specifically cited Hermon More's 1931 statement that it was not the Whitney's "intention to found a 'school'": "Although...we do not contend that [the Whitney] has founded a school...[it] has discouraged experimentation and created a situation inimical to the true development of the individual artist and American art."[25]

In a press release issued on April 27, 1960, Goodrich refuted their contentions point by point. However, he freely acknowledged that "the abstract trend is dominant, particularly among the younger generation."[26] What is clear in both the press release and in letters Goodrich wrote at the time is that the Whitney's position vis-à-vis realist artists was reaffirmed but also strained by the incident. In a letter to his old schoolmate, the artist Henry Schnackenberg, who had criticized the Whitney for being too undiscriminating in its selection of abstract art for exhibition, Goodrich reports on a visit with seven of the twenty-two artists: "it became plain that much of their criticism was not really aimed at us, but at museums in general—especially our next-door neighbor [MoMA]—and at the art magazines." However, despite his close friendships with many of these realist artists and his affinity for their work, Goodrich does not give way under pressure nor hesitate to take a stand in favor of abstract art, which they saw as having "no validity." "My answer was that we disagree fundamentally with them on this point; that we believe that the best of abstract art is completely valid, and that our job is to recognize the best in all tendencies."[27]

While Goodrich judiciously and passionately defended the Whitney's position time and again, it was John I.H. Baur, the Yale-educated art historian, who articulated a more sophisticated historical and philosophical reasoning for the Whitney's viewpoint, a viewpoint which had previously been based more on sentiment and tradition than on rational argument. When Baur joined the Whitney as associate director in 1958, he had already established himself as an art historian and curator of considerable standing. In 1951 he published his landmark volume, *Revolution and Tradition in Modern American Art*. Although written while he was a curator at The Brooklyn Museum, it expresses a clear sympathy for the Whitney's historical commitment to a stylistic democracy: "The great diversity of our modern art is a measure, I believe, of its strength and vitality.... I believe that there is still such genuine vitality in movements as far apart as abstraction and extreme realism that no fair picture of our art can afford to ignore either one or the other."[28]

Whereas Goodrich's statements tend to leave off there, Baur attempts in an almost scientific fashion to study "the underlying patterns of growth in our art, to show the broad paths along which it has moved and is now moving and to map the course of these as they cross and recross, join and separate in an order that is complex but comprehensible."[29] In this concise treatise, Baur tried to define a dialectical relationship between the revolutionary and the traditional and modernism and realism. His method was Hegelian: conflicting styles and approaches are not avoided but rather accepted as part of a complex historical reality. And he found the conceptual foundation for what the Whitney had been advocating all along: the ethical, art historical imperative to exhibit and collect a complete range of artistic production at any given moment. For to exhibit only one or a few stylistic directions was to potentially fall prey to fashion and misjudgment (something the Whitney was always accused of anyway.) By way of example, Baur reminded the reader that only recently had the Hudson River School been reinstated as an art historically significant movement.

Baur, like Goodrich, took a long view of American art history. To him, abstract art was perhaps *the* major aesthetic development in the twentieth century. Nevertheless, it was a phase, not the end toward which all art was progressing. As he wrote, presciently, "I personally do not believe that the current dominance of abstract art is necessarily permanent;

and I feel that other trends will make themselves felt increasingly. May I say that this belief is shared by my colleagues of the Museum staff."[30]

In 1958, shortly after he arrived at the Whitney, Baur organized a thematic exhibition, perhaps the most important of his career, in which he boldly announced his theoretical and artistic commitments. "Nature in Abstraction: The Relation of Abstract Painting and Sculpture to Nature in Twentieth-Century American Art" traveled to six major American museums and featured fifty-eight artists, ranging from Mark Tobey and Isamu Noguchi to Franz Kline and Louise Bourgeois. Baur begins his catalogue essay by stating that "most of our abstract painting and sculpture pays small fealty to the concepts of those pure abstractionists, who hold that the work of art should be ... of solely esthetic significance."[31] He tries to demonstrate that the opposition between abstraction and nature is to a great degree a fallacy, that the relationship is better perceived as a continuum. In essence, Baur makes the case for a wide range of aesthetic expressions by showing that nature in the broadest sense has some connection to even the most non-objective forms. Nor is his position "in any sense a reactionary back-to-nature thesis,"[32] but rather one consistent with the historically progressive stance taken by the Whitney. Like his predecessors, his commitment to and respect for the individual artist, as well as the art object, marks his method. Accordingly, his essay was "based on answers to a questionnaire, which was sent to all the living artists represented" in the exhibition.[33]

Baur was determined to give definition and art historical substance to the Whitney's catholic position, a task that was to prove difficult if not impossible given the breadth, inconsistency, and oppositional character of contemporary American art in the 1960s and early 1970s, not to mention the tumultuous politics within and among New York art museums. In a culture such as ours, defined by extremes, to take a position that may be seen as eclectic, indecisive, and schizophrenic, or to present exhibitions that seem "scattered, contradictory and disharmonious" is perhaps the most radical position of all.[34] In discussing his opposition to partisan criticism, Baur wrote that one has "to meet the artist on his own ground and understand his aims ... whether those are profound or slight and to what extent the artist has succeeded in fulfilling them."[35] Baur believed that to use "a different measuring stick is not ... a sign of vacillation ... it is rather the only way of understanding and relating the great variety of ways in which man has exercised his creative talents."[36] A similar attitude may be used to gauge the Whitney's art historical function so that it too may someday be understood on its own ground. Or perhaps misunderstanding comes with the territory.

Notes

1. See Peter Schjeldahl, "The Whitney Controversy," in *The 7 Days Art Columns, 1988–1990* (Great Barrington, Massachusetts: The Figures, 1990), p. 184. In an essay defending the Whitney's commitment to contemporary art, Schjeldahl writes that it is considered "common knowledge that the Museum's record is somehow deplorable: *trendy* is a frequent epithet...."

2. Clement Greenberg, reviewing the 1946 Whitney Annual, wrote: "Yet in view of the *evenness* with which the Whitney shows have been bad, the suspicion grows that a more considerable part of the blame than one used to think is assignable to those who run the place. Their lack of strong-mindedness, of serious bias, of any intense and constant perception of the tasks of modern art and of the direction in which it solves them best, their eclectic conformism, their eagerness to receive and their dread of finding, their affable timidity—all this creates something in its own image, and that image is any Whitney Annual as a whole"; see Clement Greenberg, *The Collected Essays and Criticism, Volume 2*, John O'Brian, ed. (Chicago and London: University of Chicago Press, 1986), p. 117.

3. "Announcement: The Whitney Museum of American Art" [1930], p. 1, Whitney Museum Archives, history box 15, file 9, 1931.

4. Gertrude Vanderbilt Whitney, "The Importance of America's Art to America," n.d., p. 1, Whitney Museum Archives, history box 15, file 9, 1931.

5. Ibid., p. 18.

6. Avis Berman, *Rebels on Eighth Street: Juliana Force and the Whitney Museum of American Art* (New York: Atheneum, 1990), p. 73.

7. Ibid., pp. 113–14.

8. John I.H. Baur, *Revolution and Tradition in Modern American Art* (Cambridge, Massachusetts: Harvard University Press, 1951), p. 128.

9. It was unrestricted individualism that enabled the Vanderbilt family to amass its fortune and Juliana Force to rise to the position of director of the Whitney from very humble beginnings.

10. Until 1940, each artist, after having been selected by the Annual or Biennial curators, selected his or her own works for exhibition.

11. Quoted in Lloyd Goodrich, "The Whitney's Battle for U.S. Art," *Art News*, 53 (November 1954), p. 38.

12. Stuart Davis, reminiscing about the Whitney with Hermon More and Jack Baur, said, "the Museum in its early days played a unique role in giving the American artist the public importance that he actually should have had...there was no other center.... The idea of the free individual artist who had his own right to explore and investigate and find ways outside of the accepted norm of picturemaking"; Hermon More and Jack Baur, "Recollections of the Whitney," interview with Stuart Davis for WNYC American Art Festival, p. 9, Whitney Museum Archives, history box 15, file 5, 1953.

13. Lloyd Goodrich, "Essay on War and Liberalism," p. 2, Whitney Museum Archives, history box 15, file 30, 1953: "[The Museum's] standards are not those of any particular school, but of essential artistic quality within each school. On the other hand, the Museum has never attempted to present a mathematical cross-section of all contemporary art, but rather its most vital and significant manifestations."

14. The Whitney Museum throughout its history has been accused of supporting secondary work. For example, John Canaday wrote in 1960: "The Museum of Modern Art is quickest in dealing with the most arresting

developments, and thus leaves the Whitney to record the latest shock-wave once-removed and weakened, along with the keeping of other records that are just as important but not shocking at all"; Canaday, "Seismography and Census-Taking: The Museum of Modern Art and the Whitney," in *Embattled Critic: Views on Modern Art* (New York: Farrar, Straus and Cudahy, 1959), p. 190.

15. Hermon More, "Introduction," *Whitney Museum of American Art: Catalogue of the Collection* (New York: William Edwin Rudge, 1931), pp. 10–11.

16. "It is a belief in the diversity of contemporary art.... We find co-existing side by side (though not always peaceably) artists of every variety of traditionalism and innovation. To our minds these many varieties have their measure of validity.... Hence our annual exhibitions show a variety of styles and viewpoints, which, I am well aware, is deplored by many artists and critics"; Lloyd Goodrich, transcript of talk given at a symposium at The Club, February 13, 1953, Whitney Museum Archives, history box 15, file 20.

17. Although the Whitney did not champion abstract art over other forms (this was the stated position of another institution, the Museum of Non-Objective Art, founded in 1937), it did consistently advocate the significance of abstraction. The landmark exhibition "Abstract Painting in America," held in 1935 and organized by Hermon More and Karl Free, with a catalogue introduction by Stuart Davis, was the first of its kind and anticipated the founding of the American Abstract Artists group. Arshile Gorky, whose work prefigures Abstract Expressionism, exhibited his abstract *Painting* (1936–37) in the 1937 Annual. Purchased out of the exhibition, it was the first Gorky to be acquired by an American museum.

Many of the major figures of Abstract Expressionism were shown in Biennials during the later years of Juliana Force's directorship. Robert Motherwell's and William Baziotes' work was exhibited in 1945, Jackson Pollock's in 1946, and Willem de Kooning's in 1948. Philip Guston began showing realist work in the 1938 Annual and was shown throughout his lifetime in twenty-five Biennials and Annuals.

While the Whitney's record of exhibiting abstract art was often daring and advanced, its acquisition record was less adventurous, especially during the period of Abstract Expressionism. The Museum did acquire Adolph Gottlieb's *Vigil* and Robert Motherwell's *Red Skirt* in 1949, but was late and rather half-hearted in acquiring its one and only Pollock in 1953. The Whitney's first de Kooning, *Woman and Bicycle*, was acquired in 1955, Guston's *Dial* in 1956, and Kline's *Mahoning* in 1957. The Museum completely missed the boat with Newman and Rothko, who did not have works in the collection until 1967 and 1968, respectively.

18. More's position was reiterated almost twenty years later, when he co-authored "A Statement on Modern Art" with the directors and curators of The Institute of Contemporary Art in Boston and The Museum of Modern Art, responding to what came to be called the "Modern Art Controversy." In 1948, Boston's Institute of Modern Art, in a reactionary display, changed its name to The Institute of Contemporary Art, citing the incomprehensibility and inaccessibility of "modern" abstract art. They insisted that artists needed to develop a "strong clear affirmation for humanity." The statement issued a year and a half later, in March 1950, was intended to clarify "current controversial issues about modern art, which are confusing to the public and harmful to the artist." Some of the language sounds remarkably similar to More's 1931 introduction to the Whitney Museum *Catalogue of the Collection*. The closing paragraphs state: "We believe that it is not a museum's function to try to control the course of art or to tell the artist what he shall or shall not do; or to impose its tastes dogmatically upon the public. A museum's proper function, in our opinion, is to survey what artists are doing, as objectively as possible.... We believe that there is urgent need for an objective and open-minded attitude toward the art of our time, and for an

affirmative faith to match the creative energy and integrity of the living artist"; copy of statement in the Whitney Museum Archives, history box 15, file 16, 1950.

19. Goodrich further wrote: "In the past the Whitney Museum's showing of successive trends among younger artists—expressionism, the American scene, social realism—met with the same kind of criticism as its present showing of abstraction and Surrealism. To surrender to such opposition and confine its activities to the popularly acceptable would be to betray its primary duty to the public, to the artist and to the future"; Goodrich, "Essay on War and Liberalism," p. 3.

20. Lloyd Goodrich, "The Problem of Subject Matter and Abstract Esthetics in Painting," 1933, p. 7, Whitney Museum Archives, administration box H2, files 59–69, 1930–39.

21. Lloyd Goodrich, "Past, Present and Future," *Art in America*, 54 (September–October 1966), p. 31.

22. Ibid., pp. 30–31.

23. The two passages about MoMA's collection are quoted in Alfred H. Barr Jr., *Painting and Sculpture in The Museum of Modern Art, 1929–1967* (New York: The Museum of Modern Art, 1977), pp. 623 and 633, respectively.

24. Canaday, "Seismography and Census-Taking," pp. 189, 191.

25. Copy of letter to Lloyd Goodrich, [1960], Whitney Museum Archives, Abstract Art Controversy Correspondence, box H4, file 82.

26. Lloyd Goodrich, press release, April 27, 1960, ibid.

27. Lloyd Goodrich, letter to Henry Schnakenberg, June 8, 1940, ibid.

28. Baur, *Revolution and Tradition in Modern American Art*, p. vii.

29. Ibid.

30. John I.H. Baur, "The Whitney and American Art," Whitney Museum Archives, history box 16, file 26.

31. John I.H. Baur, *Nature in Abstraction: The Relation of Abstract Painting and Sculpture to Nature in Twentieth-Century American Art*, exh. cat. (New York: Whitney Museum of American Art, 1958), p. 5.

32. Ibid.

33. Ibid., p. 6.

34. Canaday, "Seismography and Census-Taking," p. 192.

35. John I.H. Baur, statement, n.d., Whitney Museum Library Files, Art World Personalities.

36. Ibid.

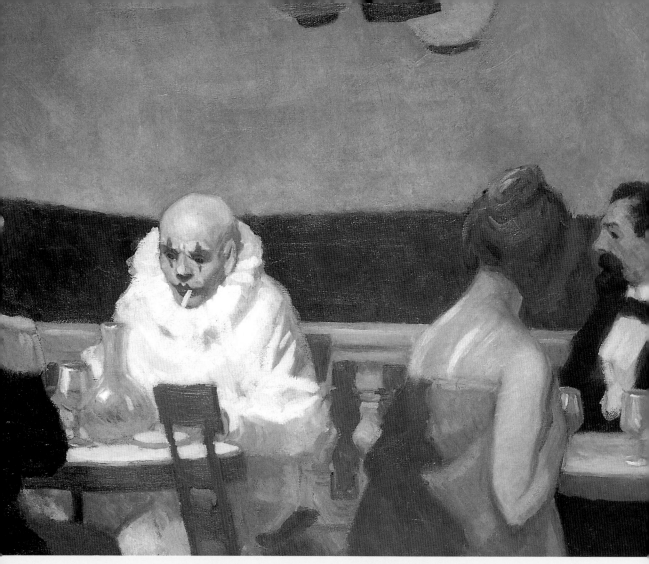

Edward Hopper
Soir Bleu, 1914 (detail)

"American Type Painting"
Sandy Nairne

"At the moment abstract and semi-abstract art is in the ascendancy, but it would be a brave critic who would dare predict what the future balance between these and the representational modes of painting will be." — John I.H. Baur, 1951[1]

For many years the struggle between the figurative and the abstract appeared to viewers across the Atlantic as the spectacular division in American art. Then the development and "triumph" of abstract art was proclaimed a clear victor.[2] And for twenty-five years after John Baur's 1951 book, it would have been difficult to assert a serious place for the importance of realist traditions within "Modern American Art." However, the image of a struggle between abstract and figurative art obscured the larger field of modernism within which it took place, and blocked a broader, emerging perspective on American art of the past hundred years.

Writing about American art from a British viewpoint can induce dangerous generalizations about nationality, intentionality, interpretation, and interconnection. This third "View from Abroad" puts forward "American Realities": an argument about the "real" that emerges from the correspondences and differences between British and American art which provoked our joint selection.[3]

The exhibition argues that a determined drive for the "real," the presentation of the real world *in* new ways (singularly charged because of the extraordinary "new" and modernized world to be portrayed) and the creation of painting, sculpture, and new media works as new forms *of* the real (in the sense of their existence as objects in the world around us) — that this is a peculiarly American phenomenon, marking points of distinction from European counterparts. In this latter sense, the extraordinary achievement of the Abstract Expressionists may also be assessed as the creation of a transcendent "real" related both to Jewish mysticism and to the materiality written about by Clement Greenberg. The exhibition proposes that there is much to revalue in self-consciously realist painting, whether from the pre-World War I period or from the forties and fifties, some of it relating closely to later and consciously neo-avant-garde forms of art.[4]

Thinking about American ideas of the real in the context of European developments should take into account their common histories and many correspondences, whether the American participation in the original European modernist avant-garde (as artists, patrons, writers, or collectors), interwar American Scene painting and European equivalents, or the avant-garde European refugees of the 1930s and their stimulation of a postwar avant-garde on the East Coast, or American and European approaches to Conceptual Art. More specific correspondences can be found with British developments. Before tracing the five

thematic sections of the exhibition, three intersections are offered here, each demonstrating a different aspect of the "real," each illuminating the issue of what might be modern and American from a British perspective.

First, Edward Hopper probably met Walter Sickert in London or Paris. Hopper shared the older artist's interest in reinterpreting the characteristic views of modern Impressionist street scenes, and his chopped-off perspectives and awkward views of the Paris quais compare with Sickert's views of Dieppe.[5] Hopper and Sickert also shared an interest in the darker symbolism of modern city life, in its daily sense of the theatrical, a painterly equivalent perhaps to the sensational reporting in the burgeoning pictorial journals. Both were cosmopolitan figures, both part of peer groups much taken with music hall and cabaret. By 1914 Hopper had painted *Soir Bleu*, a stylized café scene with the "artist" drinking with the "clown" and the "general" and confronted by the "prostitute."[6] In 1915, Sickert painted two versions of the *Brighton Pierrots*, a scene from the Brighton beachfront, where the strangely cut angles of the players and the heightened color tones create an ironic play between leisure and warfare beyond the Channel. Both paintings display a theatrical realism, both give a sense of the cinematic, of sequential moments in time: theatricality itself becomes a vehicle for exposing the truths behind modern experience.[7] From this common and definitely modern starting point, Hopper constructed some of the most stereotypical images (or staged portraits) of modern America.

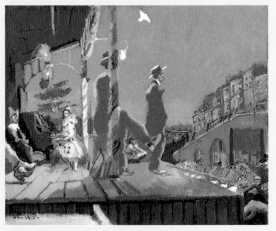

Walter Richard Sickert
Brighton Pierrots, 1915
Oil on canvas, 25 x 30 (63.5 x 76.2)
Tate Gallery, London; Purchased with assistance from the National Art Collections Fund and the Friends of the Tate Gallery

Secondly, in a conversation with Clement Greenberg in London in 1959, the British painter and writer Patrick Heron referred to "American Type Painting" as a way of identifying the by then well-established abstract and expressionist style, a style consciously anti-regionalist and anti-nationalist. Greenberg reported this in a footnote to the first edition of *Art and Culture* while discussing the various forms of abstract painting current in Europe as well as America.[8] It is appropriate that the naming should come from Heron. The group of abstract painters that had developed in St. Ives in the postwar period in the wake of Ben Nicholson and Barbara Hepworth, including Heron, Peter Lanyon, Terry Frost, and Roger Hilton, had close relations with their counterparts in New York. They exhibited there, and the creation of a new, more direct and expressive painting felt like a common enterprise, as it also did for artists working in Montreal. "American Type Painting," in its boldness, colorfulness, scale, and seriousness, was a powerful foil to the tasteful, domestic, and constraining aspects of much modern British work. It was a view of painting that found a new, expressive reality in the paint; something as real as life itself. Within a very few years, the expanding critical approval for the American artists had been matched by the growth of a powerful American market,

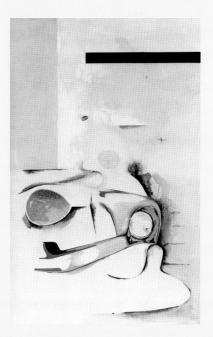

and Canadian, British, French, and Italian artists were finding it very much harder to gain the same recognition for their work.

Thirdly, the Independent Group in London became the focus for the emergence of Pop Art in Britain. Richard Hamilton's 1956 collage *Just what is it that makes today's homes so different, so appealing* or the Tate's recently acquired *Hommage à Chrysler Corp.* of 1957 were manifesto works for a critical engagement with American postwar popular culture, seen by IG artists not as a threat to British traditions, but as revitalizing and modernizing, embracing cinema, design, and fashion. Pop Art affirmed the validity of popular culture as real culture, and the culture of real people.[9] The British work was always more critical than affirmative, and the ironies in Roy Lichtenstein's or Andy Warhol's works were quickly appreciated by British viewers. Lichtenstein's *Whaam!* of 1963, purchased in 1966, is one of the great American icons in the Tate's collection (along with Mark Rothko's sublime murals for the Four Seasons restaurant in the Seagram Building). *Whaam!* offers an intersection between everyday comic-strip material and military violence (characterizing modern warfare and cannily anticipating the full violence of the Top Gun smart bomb TV replays of the Gulf War). Whatever its bold, jokey brilliance, it can be read as a painting from an allied but more powerful nation. It pictures (and punctures) a knowingly smug view of America as *the* world power. From the reality of a Pop perspective, art was not just emphatically part of an English language culture, but one of military and commercial domination as well. The critic and curator Lawrence Alloway, founding IG member, defended the new order: "I have been accused ... of being Americanised and, since I am English, thus becoming a decadent islander, half-way between two cultures. I doubt that I have lost more by my taste for the American mass media (which are better than anyone else's) than have those older writers who look to the Mediterranean as the 'cradle of civilization.'"[10]

Richard Hamilton
Hommage à Chrysler Corp.,
1957
Oil, metal foil, and collage on wood
48 x 31⅞ (122.0 x 81.0)
Tate Gallery, London;
Purchased with assistance from the National Art Collections Fund and the Friends of the Tate Gallery

These three intersections, highlighting very different aspects of the "real," are starting points for the "American Realities" of this exhibition. Forty years after Alloway's remark, British attitudes to America and Americanization are both enthusiastic and equivocal. Since the inauguration of cheap airfares in the 1960s (for the generation of Richard Long and Art & Language), the concept of nationality should have been dissipated as much by travel and familiarity (and the wider use of English as the art world's first language) as by a common cosmopolitan or modernist ideal. Yet over the past twenty years, "local" strands are as evident in London as in New York, and new and violent nationalisms have arisen in Europe. Identity politics, inherent in the feminist movement and in the expressions of cultural diversity, have provided a necessary backdrop to an art of the "real" that is simultaneously local and international, a condition as true for Mary Kelly, Jenny Holzer, Jimmie Durham, or David Hammons as it was for Arshile Gorky or Alice Neel.

1 The Subject

"All my favorite painters are abstractionists: Morris Louis and Clyfford Still. I don't do realism. I do a combination of realism and expressionism. I hate the New Realism. I hate equating a person and a room and a chair." — Alice Neel [11]

Alice Neel's famous portrait of Andy Warhol was painted in 1970, two years after the near-fatal assassination attempt on Warhol by Valerie Solanis. With his eyes closed and his scars exposed, Warhol conveys a brief sense of vulnerability; he is a person and not a machine. Gorky's great painting, *The Artist and His Mother*, establishes multiple identities for the "subject," and the nakedness of Larry Rivers' *Double Portrait of Berdie* extends the effect to a sense of almost literal intrusion. These are "psychological" portraits by which the "subject" emerges through an emotional network with the artist and viewer. A more confrontational approach is evident in John Sloan's *The Hawk (Yolande in a Large Hat)*, described by Sloan as a "very bright nervous bird-like young lady of seventeen years," [12] Nan Goldin's *Siobhan in the Shower*, and Chuck Close's *Phil*. Reality, conveyed illusionistically, as direct portrayal, might be imagined as the end point of realism in art, but the Close demonstrates that "super-realism" adds an impossible layer of visual information, in which we as viewers are reflected back, as the subject of a gaze from the work itself.

Richard Diebenkorn's *Girl Looking at Landscape* and Edward Hopper's *A Woman in the Sun* contrast in paint, surface, and gesture: the first translucent, the second graphic; the first almost abstract, the second highly narrative. But both suggest that viewer joins artist in a commanding position over the image and subject. Hopper had been praised earlier for an "intimacy ... which carries him into Romanticism.... It is also realism brought to such a degree of perception that it becomes a Romantic sorcery, seen in a crystal, crystal clear." [13] The Diebenkorn is equally intimate, if less intrusive, suffused with a wonderful, western light. The paintings demonstrate two crucial strands of "American Type Painting," neither of them the abstract kind that Greenberg had in mind, each adding, from a British viewpoint, a quiet intensity of scene, color, and perspective.

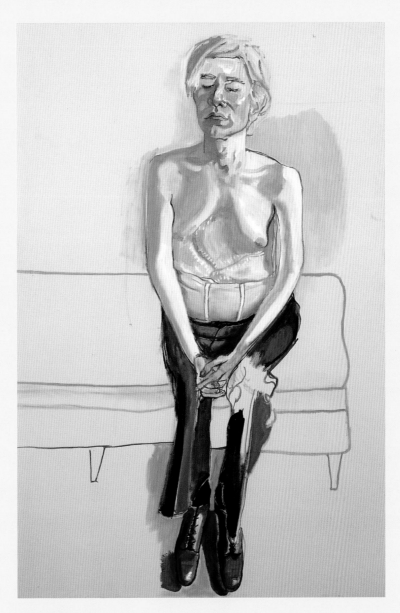

Alice Neel

Andy Warhol, 1970

Arshile Gorky
The Artist and His Mother, c. 1926-36

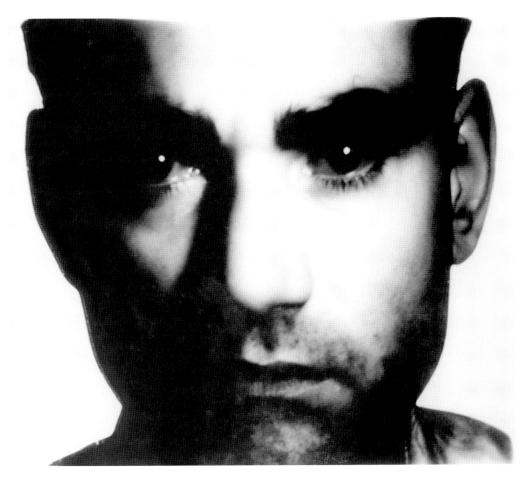

Peter Campus

Head of a Man with Death on His Mind, 1978

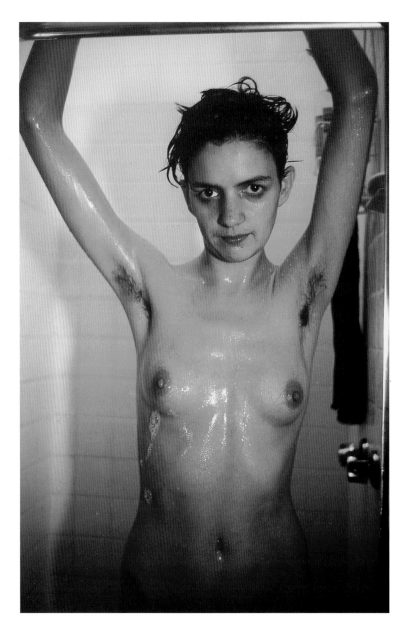

Nan Goldin

Siobhan in the Shower, 1991

Larry Rivers

Double Portrait of Berdie, 1955

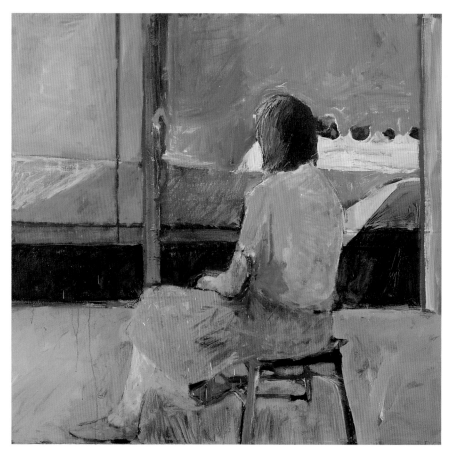

Richard Diebenkorn
Girl Looking at Landscape, 1957

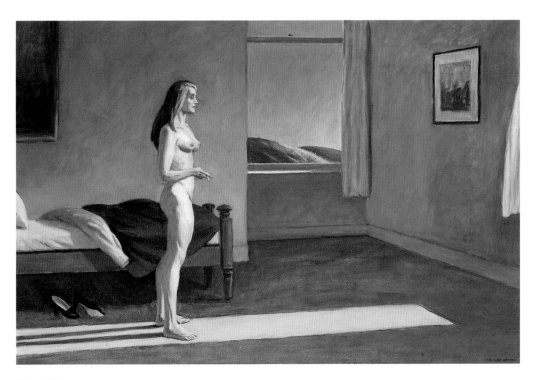

Edward Hopper
A Woman in the Sun, 1961

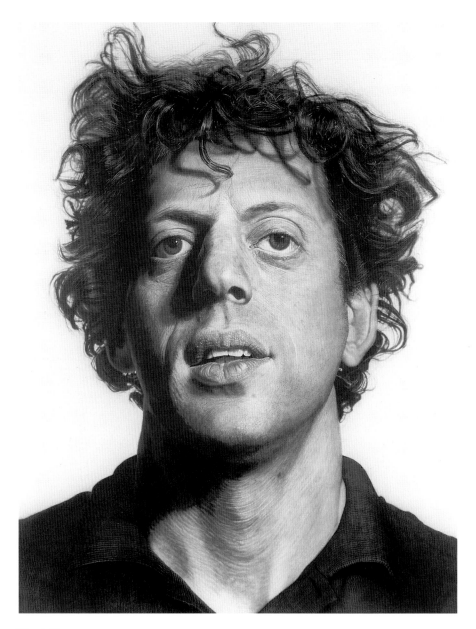

Chuck Close
Phil, 1969

Raphael Soyer

Office Girls, 1936

2 Metaphysical Landscapes

"I don't have any special affection for horses.... For years I didn't give much thought to why I was using a horse. I just thought about wholes and parts, figures and space.... If I could paint a painting about New York City, how would I do it? If I wanted to paint a landscape, would I choose a panorama or a blade of grass?"—Susan Rothenberg[14]

Both Marsden Hartley's *Forms Abstracted* of 1913 and Susan Rothenberg's *For the Light* of 1978–79 extend the concept of landscape. They are paintings whose particular painterly characteristics—depth, color, and texture—seem to relate to the artist's own experience in private and specific ways. We know that Hartley's paintings in Berlin related to his affections for a close male friend and to his interests in German military pageantry and motifs of Native Americans. His "symbolic landscape" represents these tensions, while Rothenberg's emerges from debates about what an "image" in painting might be in the late 1970s. Metaphysical landscapes are sets of inner and exterior tensions, a reality for modernist or postmodernist artists at either end of the century.

A certain realism invades all fantasy. Mental states, emotional, expressive, and expository, can feel as real as any view of the surrounding world; real but arbitrary, like language. Dreams, far from being abstract, are often uncannily sharp in focus. In a world after Freud and Saussure, which of us can make a complete separation between inside and out, or between the form and content of expression?[15] *The Seasons* by Lee Krasner and Franz Kline's *Mahoning* both hover between imagery and full abstraction. Krasner's colors of figures and foliage contrast with Kline's black-and-white gestural paintings of an urban surround. Her more fluid line and applied color contrast with the large, calligraphic appearance of his big brushstrokes. Both artists make play with the immediate and the spontaneous; Krasner referred to her repetitive use of certain colors: "[I] often will say very definitely this is *not* going to be red and green—but it turns out to be red and green. So I let it go that way rather than willing it into whatever color I might decide to will it. I think that's part of the excitement of the thing."[16]

Marsden Hartley

Forms Abstracted, 1913

Louise Bourgeois
Quarantania, 1941

Susan Rothenberg
For the Light, 1978-79

Franz Kline
Mahoning, 1956

Mark di Suvero

Hankchampion, 1960

Andy Warhol
Rorschach, 1984

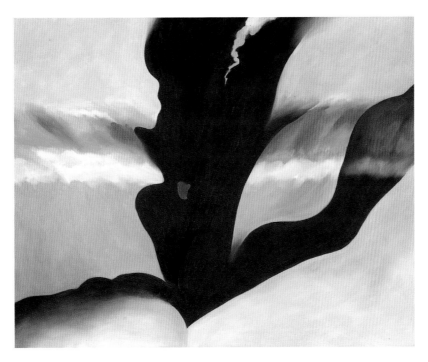

Georgia O'Keeffe
Black Place Green, 1949

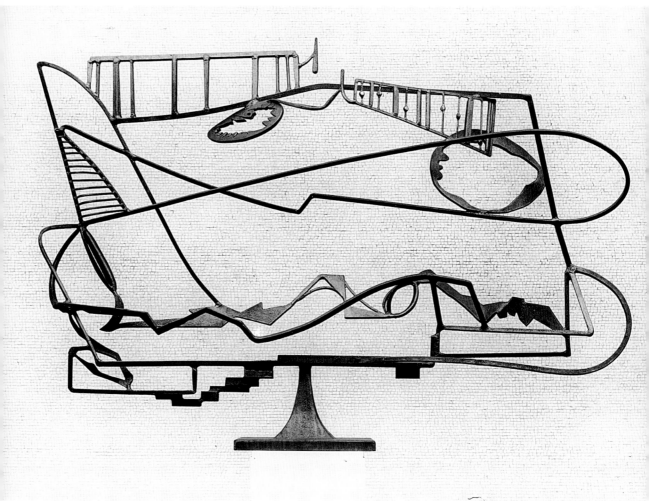

David Smith
Hudson River Landscape, 1951

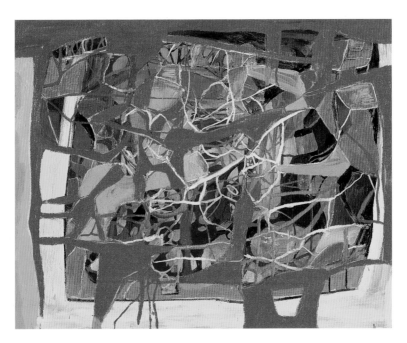

Terry Winters
Field of View, 1993

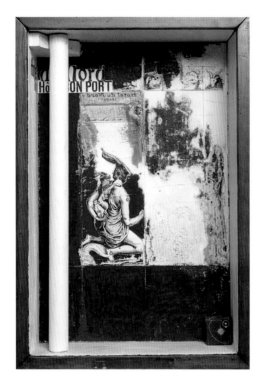

Joseph Cornell
Hôtel du Nord, c.1953

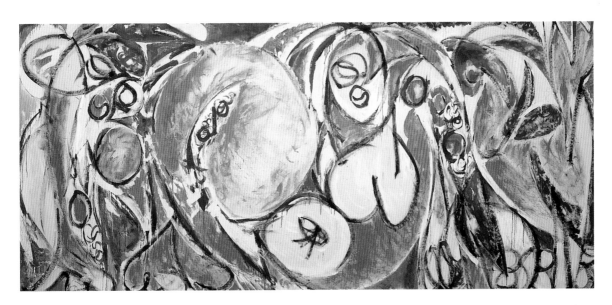

Lee Krasner

The Seasons, 1957

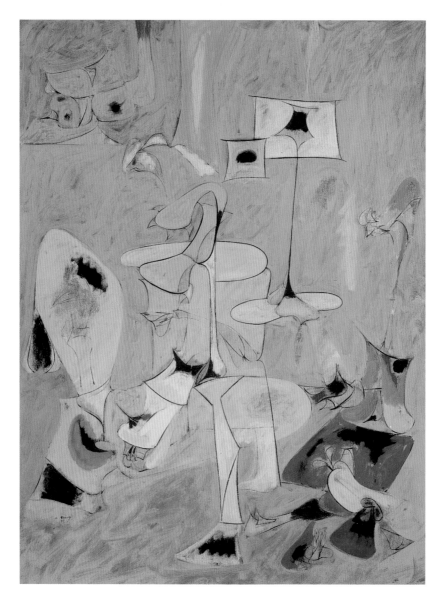

Arshile Gorky
The Betrothal, II, 1947

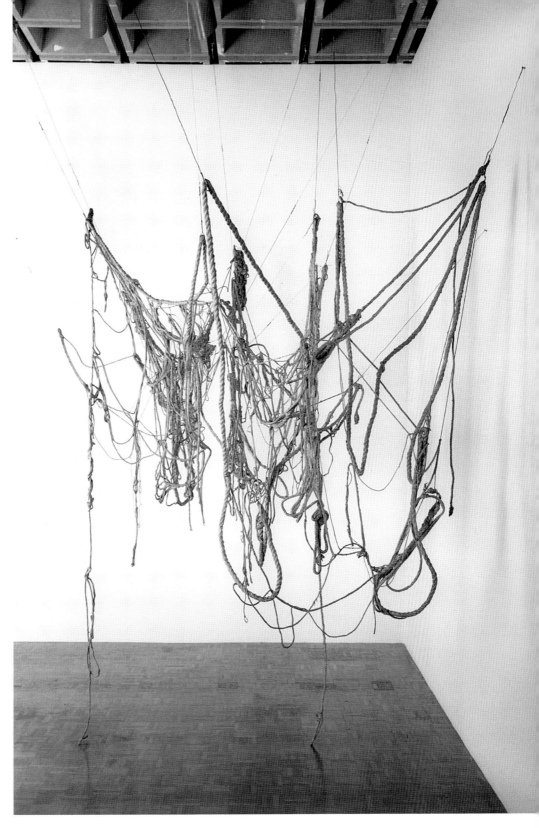

Eva Hesse
Untitled (Rope Piece), 1969-70

3 The Modern Scene

"Maybe my pictures have too much shock in them for a lot of people—especially women—to hang on the walls at home. Not really shocking, just a kind of not-too-pleasant reminder of what they have shut out when they go home.... They don't want to be reminded in their living rooms and bedrooms of the people they see—or don't see—walking on the streets of New York. Makes them feel uncomfortable."—Reginald Marsh [17]

One of the self-conscious signs of the new modern city was its evident contrasts of rich and poor, success and failure, utopia and dystopia. New American architecture of the city, of huge verticals against horizontal planes, reinforced this dichotomy. By 1900, "Seeing New York" tours were on offer, starting from the Flatiron Building and including the Bowery with "its endless procession of human wrecks." [18] This "internal tourism" is the backdrop for artists in New York, from the Ashcan School through the American Scene painters, to the supporters of *Reality* in the 1950s and on to the East Village artists of the 1980s, who themselves chose subjects, settings, and stories from the city that suggested narratives and allegories. The sense of an urban scene as, or even from, the stage is quintessentially expressed in Edward Hopper's *Early Sunday Morning*. [19] The "stage set" is evidently about to be filled, doors to open, calls and shouts to follow. A similar staging emerges in George Luks' great urban scene, *Armistice Night*, or, more recently, in Robert Longo's *Men in the Cities* series. As Christine Stansell has commented: "The new propensity for self-conscious theatricality that emerged in the early years of the century mixed in ensuing decades with the loquacious speech of various immigrant groups to create a culture of everyday, semi-public performance—comedic, pathetic, histrionic—which would become a Manhattan speciality." [20]

In contrast to the apparent aloofness of Edward Hopper or Charles Sheeler, for many American artists engagement is a necessary part of their work. Raphael Soyer put it in one way: "people are the important subject of art." [21] And his close studies of New York street life, like those of Isabel Bishop and Reginald Marsh, convey an extraordinary sense of hardship and deprivation, but also of the world of 14th Street as part of a growing metropolitan life of work and shopping (frequently portrayed, as Ellen Wiley Todd points out, with the new "New Woman" as an updated Gibson Girl). Andrew Hemingway finds that the closeness of Soyer's figures to the picture plane is particularly significant: "Like the portraits of Eakins, Soyer's down-and-outs are strongly marked as individuals but their individuality is negated by their namelessness, and the signs of their common social position." [22]

A greater political engagement informs much of the scenography of modern American art, whether in the period of the WPA or later periods of greater affluence and urban redevelopment. [23] Philip Evergood's *Through the Mill* and Martha Rosler's *The Bowery in Two Inadequate Descriptive Systems* draw the viewer into a closer consideration of cause

and effect, of working existence in the face of powerful systems of ownership and control. American artists have taken opportunities for protest to oppose social, moral, or political oppression, whether in organized campaigns or in the intrusion of their images into mainstream cultural and media spaces. As Leon Golub put it, "You can say that … anybody … who buys a work owns me, takes possession of my mind, so to speak, of my art. But then I enter his home or his situation or his environment. I put my mercenaries there."[24]

George Luks
Armistice Night, 1918

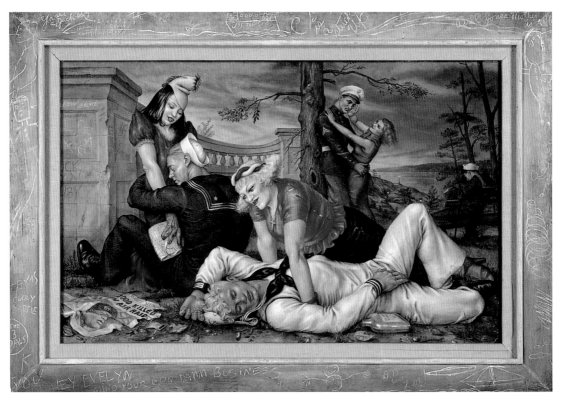

Paul Cadmus
Sailors and Floosies, 1938

Robert Longo
Untitled, 1981

Henry Koerner
Mirror of Life, 1946

Pepón Osorio

Angel: The Shoe Shiner, 1993

Stuart Davis
House and Street, 1931

Jenny Holzer
Unex Sign #1, 1983

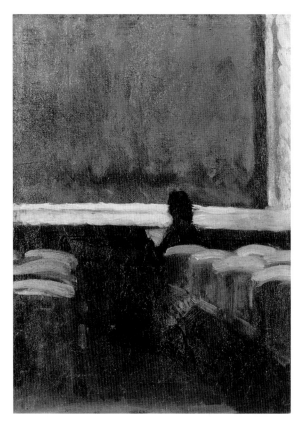

Edward Hopper
Solitary Figure in a Theater, c. 1902-04

George Segal
Walk, Don't Walk, 1976

4 Glamour and Death

"Let painting confine itself to the disposition pure and simple of color and line, and not intrigue us by associations with things we can experience more authentically elsewhere." — Clement Greenberg [25]

Andy Warhol's paintings of the early 1960s mark a conjunction between the worlds of art, commerce, and the mass media, often stained by tragedy or violence as much as by glamour or affluence. Whether in the "disaster" paintings, the *Marilyns* or in *Ethel Scull 36 Times*, the repetition of the image forces us to engage with a kind of "traumatic realism," to use Hal Foster's term. [26] Foster identifies the superfluity of the image and the sense of delay between stimulus and reaction, a concept which might be considered more widely.

The overt presence of death and violence is hardly surprising in works from the World War II and cold war years of the 1940s and 1950s. But those by Andrew Wyeth, Stephen Greene, Philip Evergood, and Jack Levine develop a specific symbolism linked to death — not as part of war or national crisis but as part of modern life, a social matter of general observation. As Stephen Greene put it: "most of my paintings have had as a subject man's final isolation, man suffering not so much for others but for himself and his own sense of incompleteness. I attempt to treat tragedy in a formalized pattern emanating from the emotion within a situation rather than the depiction of an actual scene.... It seems to me that such a sense of man is almost lost today." [27] Reality is transferred to the symbolic realm, the figurative depiction and the painterly treatment carrying a generalized but recognizable narrative. Jack Levine's *Gangster Funeral* employs painterly effects to reinforce what appears as a film scene, familiar from the screen; not yet, in the early 1950s, the subject of television or the weekly magazines.

Thirty years later, the evidence of a surrounding media frame is more complete and more invasive. Whether in Ed Paschke's *Violencia*, or Jean-Michel Basquiat's *Hollywood Africans*, the film screen is the dominant site where modern life can be interpreted. In the worlds of both art and film, the gaze has been reinforced. This goes to the very heart of modern American art, as Lawrence Alloway argued in 1959: "mass production techniques...have resulted in an expendable multitude of signs and symbols. To approach this exploding field with Renaissance-based ideas of the uniqueness of art is crippling. Acceptance of the mass media entails a shift in our notion of 'what culture is.'" [28] In a contemporary world in which glamour and death may appear as cinematic categories, Ross Bleckner's *Count No Count* becomes an almost abstract anti-glamour protest of its own: an attempt to create a memorial for the death of friends and colleagues in the AIDS epidemic.

Edward Hopper
Soir Bleu, 1914

Andy Warhol

Ethel Scull 36 Times, 1963

Philip Evergood
The Jester, 1950

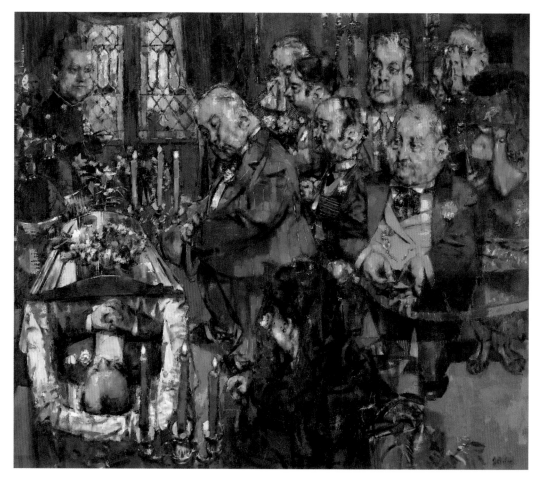

Jack Levine
Gangster Funeral, 1952-53

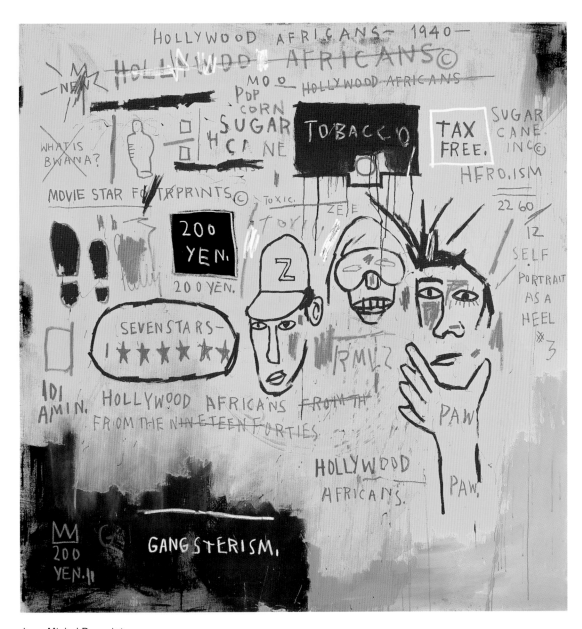

Jean-Michel Basquiat

Hollywood Africans, 1983

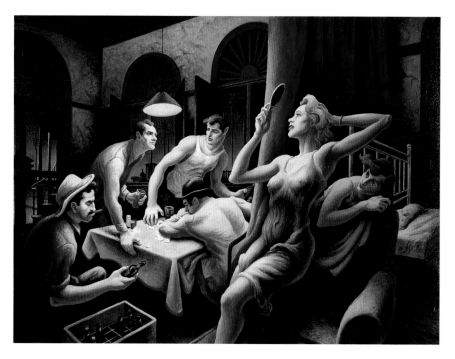

Thomas Hart Benton

Poker Night (from "A Streetcar Named Desire"), 1948

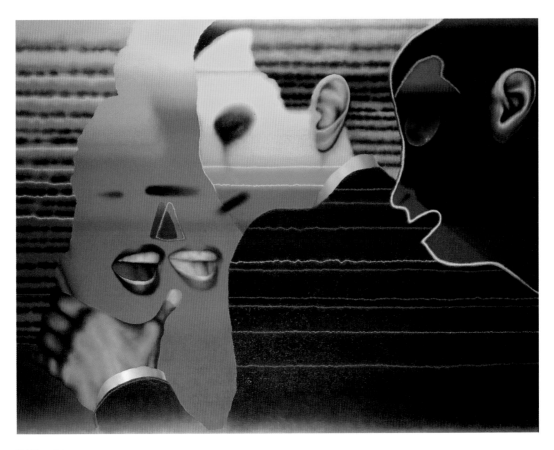

Ed Paschke
Violencia, 1980

Philip Guston
Cabal, 1977

Andres Serrano

Klansman (Knight Hawk of GA of the Invisible Empire V), 1990

Leon Golub
White Squad I, 1982

Stephen Greene
The Burial, 1947

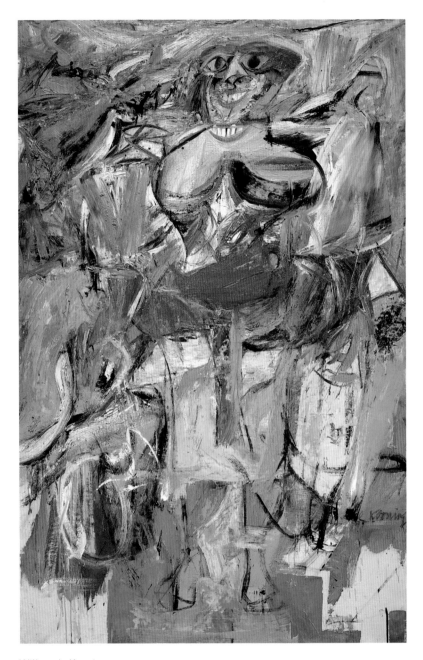

Willem de Kooning
Woman and Bicycle, 1952-53

Kiki Smith
Untitled, 1990

5 The Object

"I am concerned with a thing's not being what it was, with its becoming something other than what it is, with any moment in which one identifies a thing precisely and with the slipping away of that moment, with at any moment seeing or saying and letting it go at that." — Jasper Johns [29]

Marcel Duchamp's display of the infamous urinal in New York signaled the affinity between art and object which would emerge in America throughout the century. In Britain, this was brought to a very public display with the Tate Gallery's "bricks" affair of the later 1970s, which followed the purchase (in 1972) and display (in 1977) of Carl Andre's *Equivalent VIII*. At its core, the storm turned on the audacity with which the sculptor had nominated objects of such a workaday type to become the structural elements of his sculpture. Aesthetic issues (for example, that these are firebricks, without indentations for holding mortar) were excluded from the debate.

In Jasper Johns' *White Target*, Frank Stella's *Die Fahne Hoch*, and even Morton Schamberg's 1916 *Untitled (Mechanical Abstraction)*, there are prominent ambiguities between the painting as representation and painting as object. This peculiar, almost ghost-like relationship with the world produces a mimetic resonance: painting as part of and separated from other objects. A common desire from the 1950s to reduce art to its simplest structural forms created this specifically American ambition: an art of the real. [30]

Although divorced from any expressive content, this new concept of the real had a relationship to what had already been established through Abstract Expressionism and Color Field painting, well noted by Donald Judd in his remarks on Jackson Pollock. [31] And by Frank Stella: "I didn't want to make variations; I didn't want to record a path. I wanted to get the paint out of the can and onto the canvas. I knew a wise guy who used to make fun of my painting, but he didn't like the Abstract Expressionists either. He said they would be good painters if they could only keep the paint as good as it is in the can. And that's what I tried to do. I tried to keep the paint as good as it was in the can." [32]

The equivalent ambiguities in objecthood emerge in works by Richard Artschwager, Donald Judd, John McCracken, and Jackie Winsor. Judd's colored plexiglass serves to mask the essential structure, while Artschwager pushes the object between furniture and the fundamentals of sculpture. It is Winsor's commonplace construction materials which contrast with McCracken's high-gloss finishes, but both works are divorced from the purer simplicity of "primary structures." In each case, the bold and simple sculptural form is pursued before any pictorial composition; a direct experience is offered, an experience of the "real."

Jasper Johns
White Target, 1957

Neil Jenney
Saw and Sawed, 1969

Jim Dine
A Black Shovel, Number 2, 1962

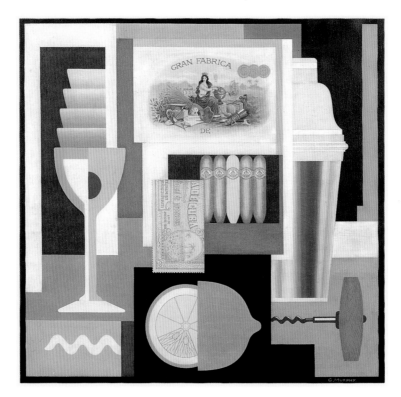

Gerald Murphy
Cocktail, 1927

Richard Artschwager
Description of Table, 1964

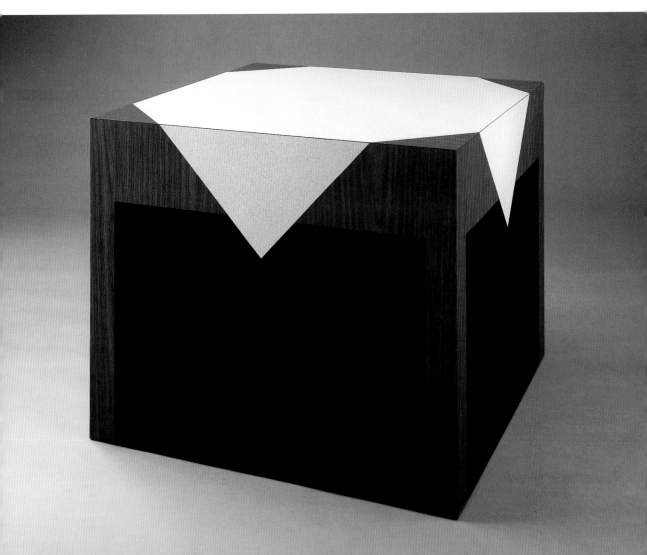

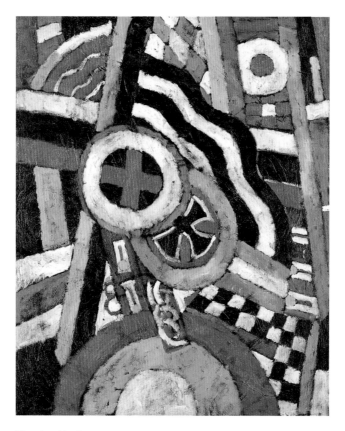

Marsden Hartley
Painting, Number 5, 1914-15

Christopher Wool
Untitled, 1990

Sol LeWitt

A six-inch (15cm) grid covering each of the four black walls. White lines to points on the grids. 1st wall: 24 lines from the center; 2nd wall: 12 lines from the midpoint of each of the sides; 3rd wall: 12 lines from each corner; 4th wall: 24 lines from the center, 12 lines from the midpoint of each of the sides, 12 lines from each corner, 1976

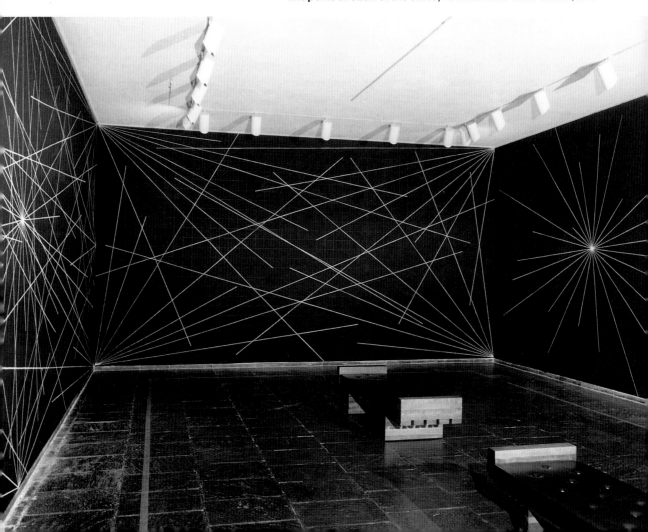

* * *

The radical American museum reformer John Cotton Dana had a vision of the modern museum as part of city life, based on the simple thesis that "the worth of a museum is in its use." In Newark, he formed a museum of museum experiments, an example that many art museums have now followed. He was circumspect about the role that museums played for artists: "The formula for producing artists still awaits discovery. The evidence seems ample that no essential part of that formula can be the presence, in rather remote and rarely visited and quite oppressive and almost gloomy buildings of high architectural endeavor, of collections of what have come to be referred to as museum objects."[33] The museum as a source is more important perhaps for artists today, but most art museums have only gradually transformed themselves into active participants, rather than passive recipients, of cultural change. The Whitney started that way, and this exhibition continues that tradition of "museum experiments" which Dana promoted.

The enterprise of "Views from Abroad" encourages the idea of opening works to new interpretations and engagements. Many "American realist" works came previously tied to a heroism of American modernism: man creating a new world. But it is striking how a contemporary reevaluation of gender roles offers new and more specific views of works by both men and women. The common framework of a self-consciously American urban modernity, the mix of nationalities and identities within it, a vibrant critical and liberal tradition of emancipation, the gradual development of a world-scale art market for contemporary and modern art—these are among the factors which may have set the stage for the particular characteristics of modern American art to emerge: a set of very particular realities.

Notes

1. John I.H. Baur, *Revolution and Tradition in Modern American Art* (Cambridge, Massachusetts: Harvard University Press, 1951), p. 145.

2. Irving Sandler's book *The Triumph of American Painting: A History of Abstract Expressionism* was published in 1970 (New York and Washington: Praeger Publishers). His introduction warns against overly formalist criticism which pays no attention to the content of the works in question. In 1974, Eva Cockcroft first published the view that the worldwide promotion of this "triumph" had specific links with US government interests; see "Abstract Expressionism: Weapon of the Cold War," *Artforum*, 12 (June 1974), pp. 39–41. This view was developed further in Serge Guilbaut's *How New York Stole the Idea of Modern Art: Abstract Expressionism, Freedom and the Cold War* (Chicago and London: University of Chicago Press, 1983). A much wider and more thorough debate continues on both sides of the Atlantic about what meanings can be invested in Abstract Expressionist paintings. See Serge Guilbaut, ed., *Reconstructing Modernism: Art in New York, Paris, and Montreal 1945–1964* (Cambridge, Massachusetts: The MIT Press, 1990); David Thistlewood, ed., *American Abstract Expressionism* (Liverpool: Liverpool University Press and Tate Gallery, Liverpool, 1993); and Michael Leja, *Reframing Abstract Expressionism: Subjectivity and Painting in the 1940s* (New Haven: Yale University Press, 1993).

3. There is an inevitable circularity in proposing an argument about American art *through* one specific collection, itself the accumulation of many arguments about what art might be modern and American. In some senses, our selection aims to reveal and expose the Whitney Museum's Permanent Collection rather than to focus on a selection of work within it.

4. Hal Foster's concepts of avant-garde, neo-avant-garde, and neo-neo-avant-garde are useful here, examining the relations in time (and not just ambition) between the "classic" modernist avant-garde artists of the early part of the century, the concerted attack on the mainstream undertaken by Process and Minimal artists in the late fifties and sixties, and the critical position pursued by later "postmodernists" working in the 1990s. See Foster, *The Return of the Real: The Avant-Garde at the End of the Century* (Cambridge, Massachusetts: An October Book, The MIT Press, 1996).

5. Sickert was born in 1860 and Hopper in 1882. Hopper would certainly have seen Sickert's paintings exhibited in Paris in 1907 and 1909. I am indebted here to Lisa Tickner's recent work on Sickert and the mass media, as presented in the 1996 Paul Mellon Lectures at the National Gallery, London.

6. Linda Nochlin describes the "solemn scaffolding" of the painting and points to the potential significance of the split in the artist figure; see "Edward Hopper and the Imagery of Alienation," *Art Journal*, 41 (Summer 1981), p. 140. When exhibited in New York, *Soir Bleu* was regarded as "too French" and not shown again in Hopper's lifetime; see Gail Levin, *Edward Hopper: The Art and the Artist* (New York: W.W. Norton & Co., 1980), p. 5.

7. See also Gail Levin, "Edward Hopper: The Influence of Theater and Film," *Arts Magazine*, 55 (October 1980), pp. 123–27.

8. Clement Greenberg, *Art and Culture* (Boston: Beacon Press, 1961), p. 209.

9. A similar legitimatization of popular culture occurred in the work of younger artists in New York in the early eighties—Cindy Sherman, Richard Prince, Robert Longo, and David Salle.

10. Lawrence Alloway, "Personal Statement," *Ark*, no. 19 (Spring 1957), excerpted in *The Independent Group: Postwar Britain and the Aesthetics of Beauty* (Cambridge, Massachusetts: The MIT Press, 1990), p. 165.

11. Alice Neel, quoted in Patricia Hills, *Alice Neel* (New York: Harry N. Abrams, 1983), p. 90.

12. Bruce St. John, ed., *John Sloan's New York Scene* (New York: Harper and Row, 1965), p. 349.

13. James Thrall Soby, *Romantic Painting in America* (1943), quoted in *Realism and Realities: The Other Side of American Painting, 1940–1960*, exh. cat. (New Brunswick, New Jersey: Rutgers University Art Gallery, 1982), p. 115.

14. Susan Rothenberg, from "An Artist's Symposium," 1982, in Kristine Stiles and Peter Selz, eds., *Theories and Documents of Contemporary Art: A Sourcebook of Artists' Writings* (Berkeley and Los Angeles: University of California Press, 1996), p. 264.

15. Writing about Jackson Pollock and the language of abstract painting, T.J. Clark suggests: "Unfounded, maybe, but perhaps for that reason rich. There is a kind of experience, these pictures propose, which is vestigial, no doubt—unusable, uncanny in the limiting sense of that word—but which at least culture leaves alone"; from "Jackson Pollock's Abstraction," in Guilbaut, *Reconstructing Modernism*, p. 198.

16. Lee Krasner, interview in Barbaralee Diamonstein, *Inside New York's Art World* (New York: Rizzoli, 1979), p. 207. For a full discussion of the "autobiographical," see Ann Middleton Wagner, *Three Artists (Three Women): Modernism and the Art of Hesse, Krasner, and O'Keeffe* (Berkeley and Los Angeles: University of California Press, 1996).

17. Reginald Marsh, 1930s, quoted in Ellen Wiley Todd, *The "New Woman" Revised: Painting and Gender Politics on Fourteenth Street* (Berkeley and Los Angeles: University of California Press, 1993), p. 206.

18. Photo caption in Rebecca Zurier, Robert W. Snyder, and Virginia M. Mecklenburg, *Metropolitan Lives: The Ashcan Artists and Their New York*, exh. cat. (Washington D.C.: National Museum of American Art, Smithsonian Institution, 1995), p. 87.

19. The artist himself seems to have been taken with the 1929 staging of Elmer Rice's play *Street Scene*; see Levin, "Edward Hopper: The Influence of Theater and Film," p. 125.

20. Christine Stansell, "What Are You Looking At?" *London Review of Books*, October 3, 1996, p. 25.

21. Raphael Soyer, interview, in *Inside New York's Art World*, p. 371.

22. Andrew Hemingway, "Critical Realism in the History of American Art," in Deborah L. Madsen, ed., *Visions of America Since 1492* (Leicester, England: Leicester University Press, 1992), p. 136. I am indebted to a number of important insights and suggestions offered by Hemingway.

23. Moses Soyer, in a 1935 review, implored artists, "Paint America, but with your eyes open. Do not glorify Main Street. Paint it as it is—mean, dirty, avaricious. Self-glorification is artistic suicide"; quoted in Patricia Hills and Roberta K. Tarbell, *The Figurative Tradition and the Whitney Museum of American Art*, exh. cat. (New York: Whitney Museum of American Art, 1980), p. 82.

24. Leon Golub, quoted in Sandy Nairne, *State of the Art* (London: Chatto & Windus, 1987), p. 172.

25. Clement Greenberg, 1944, quoted in Hills and Tarbell, *The Figurative Tradition and the Whitney Museum of American Art*, p. 130.

26. Foster, *The Return of the Real*, p. 136: "different kinds of repetition are in play in Warhol: repetitions that fix on the traumatic real, that screen it, that produce it. And this multiplicity makes for the paradox not only of images that are both affective and affectless, but also of viewers that are neither integrated (which is the ideal of most modern aesthetics: the subject composed in contemplation) nor dissolved (which is the effect of much popular culture: the subject given over to the schizo intensities of the commodity-sign)."

Ethel Scull 36 Times was described by Henry Geldzahler in 1972 as "the most successful portrait of the 1960s." After having been taken by Warhol to a photobooth, Mrs. Scull said, "I was so pleased, I think I'll go there for all my pictures from now on"; for both quotations, see Emile de Antonio and Mitch Tuchman, eds., *Painters Painting* (New York: Abbeville Press, 1984), pp. 122 and 124, respectively.

27. Stephen Greene, statement in artist's file, Whitney Museum of American Art.

28. Lawrence Alloway, "The Long Front of Culture," excerpted in *The Independent Group*, p. 165.

29. Jasper Johns to G.R. Swenson, 1964, quoted in Fred Orton, *Figuring Jasper Johns* (Cambridge, Massachussetts: Harvard University Press, 1994), p. 198.

30. "The Art of the Real" was the title of a touring exhibition, organized by The Museum of Modern Art, New York, and presented by the Arts Council of Great Britain at the Tate Gallery in 1969. The show introduced British viewers to Minimalist work, although a number of British sculptors had for some years been experimenting with process, conceptualized, and reduced forms.

31. For Judd on Pollock, see Donald Judd, *Complete Writings 1959–1975* (Halifax: The Press of the Nova Scotia College of Art and Design; New York: New York University Press, 1975), pp. 193–95.

32. Frank Stella, 1966, in Stiles and Selz, *Theories and Documents of Contemporary Art*, p. 120.

33. John Cotton Dana, *Should Museums be Useful? Possibilities in Museum Development* (Newark, New Jersey: The Newark Museum, 1927), p. 13.

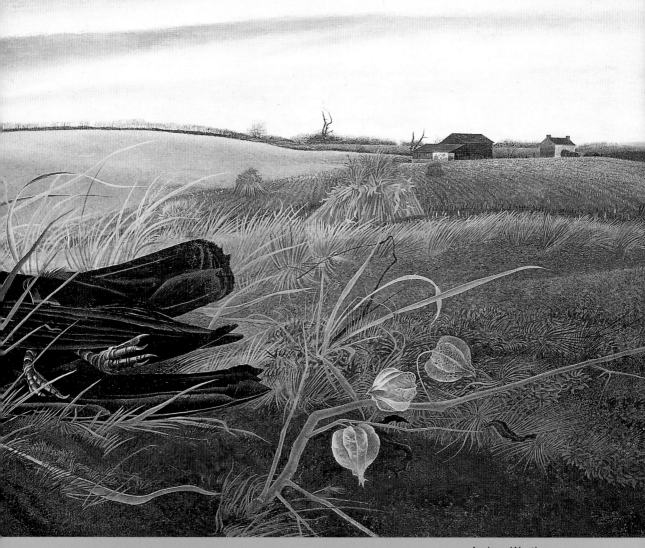

Andrew Wyeth
Winter Fields, 1942 (detail)

Clement Greenberg, Andrew Wyeth, and Serious Art

Andrew Brighton

Perhaps in the autumn of his years Clement Greenberg became mischievous. There is a story that used to be told like a joke in London: in the late seventies, the editor of a British art magazine went to see Greenberg. When asked who was the most important artist working in the USA, the critic replied, "Andrew Wyeth, but you can't quote me." "American Realities" is an exhibition that de-Greenbergs American painting. But this assumes that we know what Greenberg's views were.

There were two essays by Greenberg which were particularly influential in London in the sixties and seventies: "Avant-Garde and Kitsch," first published in 1939 and republished in the early sixties in Greenberg's anthology of essays, *Art and Culture*, and "Modernist Painting," published in 1965. They both seemed to define serious modern art. With Wyeth in mind, I want to reconsider, to reargue, some of the issues Greenberg raised, issues about the political economy of art, about the sources of aesthetic conviction, and about the boundaries of serious art.

1

Greenberg argued that serious art in modern times was essentially autonomous, while tied by a golden chain to the plutocracy. This autonomy was grounded in art's self-referentiality. Modern aesthetic sensibility is shorn of extrinsic symbolism and story-telling. This sensibility brought to bear on art's own past and on how we perceived and valued historic art a taste for what was directly experienced in a work. The modern art Greenberg found most aesthetically convincing was, he argued, the practical elaboration of this sensibility. However, Greenberg's account of autonomy requires a narrow form of attention to art. It is neither an accurate nor an encompassing description of the plurality of serious art in our times unless you exclude, for instance, the tradition of Dada, which is what Greenberg did. But serious is the crucial word here.

The fundamental and largely ignored characteristic of the modern conditions of production for art is plurality. Baudelaire bemoaned the decline of the Schools in the mid-nineteenth century; each artist had only the smallholdings of individual talent to cultivate. What Baudelaire and others foresaw was the end of a culture of art, of that institutionalized community of theory and practice which was aware of art's past, which argued about what was consequential and inconsequential, which had the power to collect and preserve what was taken to be of high value. The erosion of the academies by the rise of a middle-class art-buying audience and the growing status and influence of independent dealers and their artists threatened a dictatorship of banality: a plurality limited by the tastes of

Andrew Wyeth
Winter Fields, 1942

an inexpert buying public. Art would become incapable of seriousness; incapable of elaborating itself beyond common sentimental life, knowledge, and ideas.

What continued to concern observers from Matthew Arnold through to the Greenberg of "Avant-Garde and Kitsch" was how serious art could be viable in a modern economy. They feared the consequence of the rise of the vulgar rich. What they failed to note was how modern economies inflated the value of knowledge and the way art was for some the paradigm of the new cultural capital; it appeared autonomous, self-critical, and self-aware. Invisible to intellectuals was the political and economic rise of their own strata, the professional classes. They did not foresee that the largely artisan activity of art would increasingly be invaded by the educated, some with private incomes for whom dependency on the patronage of plutocracy was minimal or nonexistent. They underestimated the consequence of a pioneering minority of the growing professional classes who were knowledgeable collectors of ambitious and demanding contemporary art. They did not grasp that some dealers would market art for its claim to seriousness rather than its popularity. This alliance would eventually be institutionalized by museums of modern art and art historians. They did not foresee, in other words, the economic and institutional relations that sustain serious art in a modern economy.

2

Greenberg's supposed admiration for Wyeth inflames the issue of seriousness and its possibility. Wyeth has had some acknowledgment as a serious artist. There have been scholarly catalogues and books published about him. He has had major exhibitions of his

work, notably at The Metropolitan Museum of Art in 1976. He is, for instance, included in the Whitney's collection, but by only one work, given and not bought, *Winter Fields*, 1942. He also has only one work in The Museum of Modern Art. There is more at stake in Greenberg's hypothetical apostasy than just a disinterested discussion of the paintings of Andrew Wyeth.

"My reputation aside, I would like to be the curator of the proposed Andrew Wyeth exhibit," wrote the late Henry Geldzahler when the major Wyeth retrospective was being planned for the Metropolitan Museum. Subsequently, he withdrew from the project. Geldzahler said that the "constituency" he had built up over the last sixteen years as a curator at the Metropolitan would not understand why he should curate such an exhibition when there were not yet retrospectives of Pollock, de Kooning, and Gorky.

The Wyeth exhibition attracted huge audiences. Wyeth is probably America's most popular living painter, and it is his "constituency" that is part of the problem. He and his work have come to connote the middle-class, middle America, the inexpert audience that is the USA version of the historic threat to serious art. For an ambitious curator to advocate a Wyeth purchase or an exhibition was, and I suspect still is, professionally dangerous. Even though the historicist and Eurocentric accounts of modern art have been challenged, gender assumptions about the avant-garde called into question, and the distinction between low and high art supposedly abandoned, there remains one boundary of the serious art world that is ostensibly intact, the boundary with middle-class culture.

Essential to understanding how art history and the museums have institutionalized serious modern art is to see what they passed over in silence. While art for middle-class homes and inexpert purchasers is bigger business than art for serious collectors and museums, it has no history, no criticism, no place in the museum. If it appears in accounts of modern art, it is as an unexamined specter of inauthenticity, against which authentic art struggles. For example, Norman Rockwell is mentioned in Greenberg's "Avant-Garde and Kitsch" as a token for all that avant-garde painting is not. Notoriously, the nearest Greenberg got to citing a particular "kitsch" work was a reference to Ilya Repin's "battle paintings." But the Russian history painter Repin, as Greenberg came to admit, never painted a battle. An unmapped no-person's land appears to exist between serious art and what might be called consensus art. What this hides is how serious art has shaped itself in opposition to consensus art. In the histories of modern cultural conflict, we have been told little of the army against which the avant-garde has been deployed.

If taken to be important, Wyeth is particularly dangerous because his work suggests the possibility of serious art being produced outside the art historical map; he is from the terrain passed over in silence. For instance, in a museum or history that treats art as a story of historical development, the question of where Wyeth's work came from and to where it led would be an issue. His technical debt to a tradition of illustration, that of his father, N.C. Wyeth, and Howard Pyle, could lead to the suggestion that they too should

become part of the art historical narrative. Their work comes from a moment in the history of illustration when illustrators made oil or watercolor paintings for reproduction. Such paintings were fundamentally linear and tonal. The vagaries of reproduction meant that color had to be subordinate. It provided only dramatic effects. Wyeth's mature work starts in the forties by draining out all but residual color, cutting out the structurally superficial. But with these illustrators entering the door of the museum would that other absentee from the Whitney, Norman Rockwell, be far behind?

3

The problem with Wyeth, however, is not just with his audience, nor with the traditions from which he comes. It is with the nature of his seriousness, it is the ideology of the work. His work is a contradiction, it is serious popular painting, it is populist. And it can be seen as an almost systematic antithesis to the argument of Greenberg's "Modernist Painting."

Much of the modern painting we know to be most popular through the sale of reproductions realizes the intelligentsia's nightmare of banality—artifacts made, called, and treated as art but without any developed discourse or way of apprehending that attends to them as art. In such paintings, well-worn conventions evoke familiar emotions and values: the beauties of nature, appealing children, soft erotica, and sympathetic animals. This is the art of peripheral vision. The values it celebrates and the emotions it excites are for the most part propagated by other more influential media. Nearly all such works have overtly painted surfaces; some evoke the style of past high art. There is also a more conceptual area of practice, hobbyist art. Here moments of sporting drama and vintage cars, ships, boats, trains, steam engines, or birds are depicted for connoisseurs of detail. Precious sentiments and values are captured in oils. However, the essential optic of most popular paintings is derived from photography. The mass media's use of photography and the other lens-based means of mechanical representation provide the core of pictorial common sense. Pictorial realism is not a question of relation to things in the world, but of a relation to photography.

To take a British example, the late Edward Seago was a painter popular in reproduction and, on a personal level, with sections of the English establishment. He was friend of the Duke of Edinburgh and taught the Prince of Wales watercolor painting. His work is not, however, represented in the national collection of British art at the Tate Gallery. He specialized in scenes of rural Norfolk in which, beyond a Cézannesque foreground, the sun dapples far-flung fields through Constableian clouds. Some rural Hodge might be tending the fields or driving a pair of shire horses before the plough, but no telephone wires, pylons, or exercising NATO jets from the many airforce bases in East Anglia shattered Seago's English countryside. Because he primed his canvases roughly, the thin paint appears to have been heavily worked, as if the product of a prolonged confrontation between painter and motif. But the extremity of Seago's tonal contrasts and the emptiness

Edward Seago
Winter Landscape, Norfolk, c. 1962–63
Oil on hardboard, 19⅜ x 29¼ (49.6 x 75)
Norwich Castle Museum

of his compositions owed much to neo-Romantic landscape photography—itself, of course, indebted to the kind of landscape painting Seago was evoking.

Wyeth, as I have said, is an exception among painters popular with an inexpert audience. For example, his debt to photography is not veiled in such painterly devices, but rather its optic is exceeded in his linear precision. Forms are known more precisely than as a mere record of light falling upon things. His mimeticism is so compelling that his means appear transparent, as if his was a painting without style. This transparency enacts the work's populism. It is the converse of Greenberg's argument that the self-conscious picture plane is the key site of modern cultivated sensibility's experience of painting. If we attend to the surface of Wyeth's paintings we encounter the aridity of tempera and extraordinary skill. High skill becomes overt when exercised in familiar pictorial conventions. The use of such conventions always risks the charge of illustration, a key term of Greenbergian disparagement. The charge is that the image and meaning have been forced

onto the canvas in indifference to the need to make the work sensitive to the material nature of the medium.

Wyeth replaces the reflexive picture plane with the puritan surface. He is not insensitive to his medium; rather he uses the meanness of tempera. His virtuosity is entirely lashed to mimeticism. Only in some of his watercolors does he exploit the aesthetic of the sketch, the assertion of a temperament between the viewer and what is depicted. Wyeth's work incites us to believe that with our everyday capacity to read faces, stance, and objects we can understand these paintings and that they do not require the cultivation of a special sensibility, mode of attention, and knowledge of art.

There is a contradiction: Wyeth's work rewards informed reflection in a way that the vast majority of popular painting does not. For instance, the more you examine Seago's devices, the more obvious it is that the work is there to say more agreeably what has already been said; his paintings are like landscapes glimpsed from a comfortable train. Against this, Wyeth's best work is deeply pessimistic and extreme. He brings a prodigious technique informed by Northern European painting as well as the tradition of Pyle and his father. His sophisticated manipulation of the viewer's pictorial position is at times cinematic. In *Winter's Field*, the eye of the viewer is low and so close to the dead bird as to turn it into a mountain in the landscape. At other times, we are raised above the ground as in a boom shot, looking down and insecure. In the precision of Wyeth's depiction there is an almost theological belief in the value of the direct physical experience of the material world. All this is brought to bear on depicting a harsh landscape and the rural poor.

Populism hankers for a state of society in which people make their world directly, for a condition before the division of labor. In such a society, complex systems and the value and authority of professional expertise would disappear or be devalued. The self-built clapboard house constructed without architects and requiring only low-level technology, traditional skills, and manual effort might serve as an emblem of such a way of life. Wyeth depicts such a house in his paintings of the Olsons. But the house is in decay and occupied by an impoverished elderly couple, a crippled woman and her brother. They are the residue of a dead way of life, they appear to be idiots in the sense of being outside consequential social life.

4

There was an ambiguity in the nature of Greenberg's arguments. Were they descriptive or prescriptive? Was he making a distinction of kind in "Avant-Garde and Kitsch" and defining a kind of painting in "Modernist Painting"? Or was he simply offering a description of the history and sources of conviction of what were in his experience the most aesthetically telling works of his time? A definition of kind would be illegitimate to Greenberg's later position because it would allow concepts to prescribe the conceptless nature of aesthetic experience. In the Kantian tradition, aesthetic quality is experienced rather than recognized.

Arguably, Greenberg's criticism is a footnote to Alfred Barr's Museum of Modern Art. MoMA institutionalized a history of art which Greenberg glossed with the theoretical argument of "Avant-Garde and Kitsch." Greenberg's ambiguity is then another form of the old art gallery chestnut: are we collecting work of high aesthetic quality or are we recording, filling in, a historical account of art? This question goes back at least to Charles Eastlake's directorship of the National Gallery in London and remains unanswered. Museums of modern art need to sustain this ambiguity in their explicit function because, as I have argued in this essay, like art history they are complicit in sustaining artistic value as having some independence from inexpert popular taste. They are complicit in making that taste invisible. Presumably a proper history of art would begin as a history of what was produced, bought, sold, and used as art. It would be prior to any judgments of aesthetic value.

A museum of art chosen on grounds of quality alone would not be arranged chronologically. Perhaps an answer is to escape from the authority of art historical hanging. Is it possible to imagine a room of Wyeth's work in the Museum für Moderne Kunst in Frankfurt? In each of the museum's rooms is displayed a group of works by one artist. There is no chronology. Each grouping of work asks for a change of aesthetic gear rather than implying some authoritative historical thread or essential quality that runs through all that is displayed. The installation asks us to attend to the particularity of the art it shows. In that context, one could more easily form a view of Wyeth's work less troubled by his institutionally anomalous position and the connotations of his audience; it would be possible to admit the plurality of serious art without abandoning it to the plurality of the market, without abandoning it to the dictatorship of popularity.

The presence of paintings by Wyeth in Frankfurt would have a further value: it could de-habituate the assumptions of institutionalized serious art. Wyeth's seriousness can help exhume for critical scrutiny some of the values and ideas tacit within the histories and museums of modern art. Further, it would remind us not to preempt ideologically the experience a work of art offers. That, perhaps, is the moral of the Greenberg story.

Works in the Exhibition

Dimensions are in inches, followed by centimeters; height precedes width precedes depth. Sight refers to a measurement taken within the frame or mat opening.

Tate Gallery

Roy Lichtenstein (b. 1923)
Whaam!, 1963
Acrylic and oil on canvas,
67⅛ x 158½ (172.7 x 406.4)
Tate Gallery, London; Purchase

Whitney Museum of American Art

Section 1: The Subject

Peter Campus (b. 1937)
Head of a Man with Death on His Mind, 1978
Video projection, dimensions variable
Promised gift of The Bohen Foundation
P.4.91

Chuck Close (b. 1940)
Phil, 1969
Synthetic polymer on canvas, 108 x 84
(274.3 x 213.4)
Purchase, with funds from Mrs. Robert M.
Benjamin 69.102

Richard Diebenkorn (1922–1993)
Girl Looking at Landscape, 1957
Oil on canvas, 59 x 60⅜ (149.9 x 153.4)
Gift of Mr. and Mrs. Alan H. Temple 61.49

Nan Goldin (b. 1953)
Siobhan in the Shower, 1991
Cibachrome print, 48 x 36 (121.9 x 91.4) sight
Gift of the artist and Pace/MacGill Gallery
92.133

Arshile Gorky (1904–1948)
The Artist and His Mother, c. 1926–36
Oil on canvas, 60 x 50 (152.4 x 127)
Gift of Julien Levy for Maro and Natasha
Gorky in memory of their father 50.17

John D. Graham (1887–1961)
Head of a Woman, 1926
Oil on canvas, 22 x 18 (55.9 x 45.7)
Gift of Gertrude Vanderbilt Whitney 31.228

Edward Hopper (1882–1967)
A Woman in the Sun, 1961
Oil on canvas, 40 x 60 (101.6 x 152.4)
50th Anniversary Gift of Mr. and Mrs.
Albert Hackett in honor of Edith and Lloyd
Goodrich 84.31

Alice Neel (1900–1984)
Andy Warhol, 1970
Oil on canvas, 60 x 40 (152.4 x 101.6)
Gift of Timothy Collins 80.52

Larry Rivers (b. 1923)
Double Portrait of Berdie, 1955
Oil on canvas, 70¾ x 82½ (179.7 x 209.6)
Gift of an anonymous donor 56.9

Cindy Sherman (b. 1954)
Untitled #109, 1982
Chromogenic print, 36¼ x 36¼ (92.1 x 92.1)
Gift of The Foundation to Life, Inc., in
memory of Eugene M. Schwartz 96.133

John Sloan (1871–1951)
The Hawk (Yolande in Large Hat), 1910
Oil on canvas, 26⁵⁄₁₆ x 32¼ (66.8 x 81.9)
50th Anniversary Gift of the John Sloan
Memorial Foundation 90.15

Raphael Soyer (1899–1987)
Office Girls, 1936
Oil on canvas, 26 x 24 (66 x 61 cm.)
Purchase 36.149

Section 2: Metaphysical Landscapes

Milton Avery (1885–1965)
Dunes and Sea II, 1960
Oil on canvas, 51⅞ x 72 (131.8 x 182.9)
50th Anniversary Gift of Sally Avery 91.60

William Baziotes (1912–1963)
Sand, 1957
Oil on canvas, 48 x 36 (121.9 x 91.4)
Lawrence H. Bloedel Bequest 77.1.6

Louise Bourgeois (b. 1911)
Quarantania, 1941
Seven wooden pine elements on a wooden
base, 84¾ x 31¼ x 29¼ (215.3 x 79.4 x 74.3)
Gift of an anonymous donor 77.80

Joseph Cornell (1903–1972)
Rose Castle, 1945
Box construction: wood, glass, mirrors,
painted branches, printed paper, painted
wood, and glitter, 11½ x 14¹⁵⁄₁₆ x 4¹⁄₁₆
(29.2 x 37.9 x 10.3)
Kay Sage Tanguy Bequest 64.51

Joseph Cornell (1903–1972)
Hôtel du Nord, c. 1953
Box construction: wood, glass, collaged
printed paper, and painted wood,
19¼ x 13¼ x 5½ (48.9 x 33.7 x 14)
Purchase 57.6

Mark di Suvero (b. 1933)
Hankchampion, 1960
Wood and chains, 77½ x 149 x 105
(196.9 x 378.5 x 266.7)
Gift of Mr. and Mrs. Robert C. Scull 73.85

Arthur G. Dove (1880–1946)
Land and Seascape, 1942
Oil on canvas, 25 x 34¾ (63.5 x 88.3)
Gift of Mr. and Mrs. N.E. Waldman 68.79

Arshile Gorky (1904–1948)
The Betrothal, II, 1947
Oil on canvas, 50¾ x 38 (128.9 x 96.5)
Purchase 50.3

Adolph Gottlieb (1903–1974)
Vigil, 1948
Oil on canvas, 36 x 48 (91.4 x 121.9)
Purchase 49.2

Philip Guston (1913–1980)
Dial, 1956
Oil on canvas, 72 x 76 (182.9 x 193)
Purchase 56.44

Marsden Hartley (1877–1943)
Forms Abstracted, 1913
Oil on canvas, 39½ x 31¾ (100.3 x 80.6)
Gift of Mr. and Mrs. Hudson D. Walker and
exchange 52.37

Eva Hesse (1936–1970)
Untitled (Rope Piece), 1969–70
Latex over rope, string, and wire,
dimensions variable
Purchase, with funds from Eli and Edythe
L. Broad, the Mrs. Percy Uris Purchase
Fund, and the Painting and Sculpture
Committee 88.17a–b

Franz Kline (1910–1962)
Mahoning, 1956
Oil and paper collage on canvas, 80 x 100
(203.2 x 254)
Purchase, with funds from the Friends of
the Whitney Museum of American Art 57.10

Lee Krasner (1908–1984)
The Seasons, 1957
Oil on canvas, 92¾ x 203¾ (235.6 x 517.5)
Purchase, with funds from Frances and
Sydney Lewis (by exchange), the Mrs.
Percy Uris Purchase Fund, and the
Painting and Sculpture Committee 87.7

Works in the Exhibition

Georgia O'Keeffe (1887–1986)
Black Place Green, 1949
Oil on canvas, 38 x 48 (96.5 x 121.9)
Promised 50th Anniversary Gift of Mr.
and Mrs. Richard D. Lombard P.17.79

Jackson Pollock (1912–1956)
Number 27, 1950
Oil on canvas, 49 x 106 (124.5 x 269.2)
Purchase 53.12

Susan Rothenberg (b. 1945)
For the Light, 1978–79
Acrylic and flashe on canvas, 105 x 87
(266.7 x 221)
Purchase, with funds from Peggy and
Richard Danziger 79.23

Mark Rothko (1903–1970)
Agitation of the Archaic, 1944
Oil on canvas, 35⅜ x 54¼ (89.9 x 137.8)
Gift of The Mark Rothko Foundation, Inc.
85.43.1

David Smith (1906–1965)
Hudson River Landscape, 1951
Welded painted steel and stainless steel,
49¹⁵⁄₁₆ x 73¾ x 16⁹⁄₁₆ (126.8 x 187.3 x 42.1)
Purchase 54.14

Andy Warhol (1925–1987)
Rorschach, 1984
Synthetic polymer on canvas, 165 x 115
(419.1 x 292.1)
Purchase, with funds from the
Contemporary Painting and Sculpture
Committee, the John I.H. Baur Purchase
Fund, the Wilfred P. and Rose J. Cohen
Purchase Fund, Mrs. Melva Bucksbaum,
and Linda and Harry Macklowe 96.279

Terry Winters (b. 1949)
Field of View, 1993
Oil and alkyd on canvas, 75¹⁵⁄₁₆ x 96⁷⁄₁₆
(192.9 x 245)
Purchase, with funds from the Painting
and Sculpture Committee 94.73

Section 3: The Modern Scene

Isabel Bishop (1902–1988)
Subway Scene, 1957–58
Egg tempera and oil on composition
board, 40 x 28 (101.6 x 71.1)
Purchase 58.55

Paul Cadmus (b. 1904)
Sailors and Floosies, 1938
Oil and tempera on panel, 25 x 39½
(63.5 x 100.3)
Gift of Malcolm S. Forbes 64.42

Stuart Davis (1892–1964)
House and Street, 1931
Oil on canvas, 26 x 42¼ (66 x 107.3)
Purchase 41.3

Charles Demuth (1883–1935)
My Egypt, 1927
Oil on composition board, 35¾ x 30
(90.8 x 76.2)
Purchase, with funds from Gertrude
Vanderbilt Whitney 31.172

Elsie Driggs (1898–1992)
Pittsburgh, 1927
Oil on canvas, 34¼ x 40 (87 x 101.6)
Gift of Gertrude Vanderbilt Whitney 31.177

Philip Evergood (1901–1973)
Through the Mill, 1940
Oil on canvas, 36 x 52 (91.4 x 132.1)
Purchase 41.24

Jenny Holzer (b. 1950)
Unex Sign #1, 1983
Spectrocolor machine with moving
graphics, 30½ x 116½ x 11⅝
(77.5 x 295.9 x 29.5)
Purchase, with funds from the Louis and
Bessie Adler Foundation, Inc., Seymour M.
Klein, President 84.8a–c

Edward Hopper (1882–1967)
Young Woman in a Studio, c. 1901–02
Oil on board, 12³⁄₁₆ x 9⁵⁄₁₆ (31 x 23.7)
Josephine N. Hopper Bequest 70.1430

Solitary Figure in a Theater, c. 1902–04
Oil on board, 12½ x 9³⁄₁₆ (31.8 x 23.3)
Josephine N. Hopper Bequest 70.1418

Man Seated on Bed, c. 1905–06
Oil on board, 11 x 8⅞ (27.9 x 22.5)
Josephine N. Hopper Bequest 70.1424

Early Sunday Morning, 1930
Oil on canvas, 35 x 60 (88.9 x 152.4)
Purchase, with funds from Gertrude
Vanderbilt Whitney 31.426

Henry Koerner (1915–1991)
Mirror of Life, 1946
Oil on composition board, 36 x 42
(91.4 x 106.7)
Purchase 48.2

Robert Longo (b. 1953)
Untitled, 1981, from the series **Men
in the Cities**
Graphite on paper, 93½ x 58¼ (237.5 x 148)
Gift of Estelle Schwartz in honor of her
parents, Dora and Abe Cohen 91.55

George Luks (1867–1933)
Armistice Night, 1918
Oil on canvas, 37 x 68¾ (94 x 174.6)
Gift of an anonymous donor 54.58

Reginald Marsh (1898–1954)
Twenty Cent Movie, 1936
Egg tempera on composition board,
30 x 40 (76.2 x 101.6)
Purchase 37.43

Pepón Osorio (b. 1955)
Angel: The Shoe Shiner, 1993
Painted wood, rubber, fabric, glass,
ceramic, shells, painted cast iron, two
video monitors, two color videotapes,
hand-tinted photographs, paper, and
mirror, dimensions variable
Purchase, with funds from the Painting
and Sculpture Committee 93.100a–s

Martha Rosler (b. 1943)
**The Bowery in Two Inadequate
Descriptive Systems**, 1974–75
Forty-five gelatin silver prints on twenty-
four backing boards, 11¹³⁄₁₆ x 25⅝
(30 x 60) each
Purchase, with funds from John L.
Steffens 93.4.1–24a–b

George Segal (b. 1924)
Walk, Don't Walk, 1976
Plaster, cement, metal, painted wood,
and electric light, 104 x 72 x 72
(264.2 x 182.9 x 182.9)
Purchase, with funds from the Louis and
Bessie Adler Foundation, Inc., Seymour M.
Klein, President; the Gilman Foundation,
Inc.; the Howard and Jean Lipman
Foundation, Inc.; and the National
Endowment for the Arts 79.4

John Sloan (1871–1951)
Sixth Avenue Elevated at Third Street,
1928
Oil on canvas, 30 x 40 (76.2 x 101.6)
Purchase 36.154

Raphael Soyer (1899–1987)
Reading from Left to Right, 1938
Oil on canvas, 26¼ x 20¼ (66.7 x 51.4)
Gift of Mrs. Emil J. Arnold in memory of
Emil J. Arnold and in honor of Lloyd
Goodrich 74.3

George Tooker (b. 1920)
The Subway, 1950
Egg tempera on composition board,
18⅛ x 36⅛ (46 x 91.8) sight
Purchase, with funds from the Juliana
Force Purchase Award 50.23

Section 4: Glamour and Death

Jean-Michel Basquiat (1960–1988)
Hollywood Africans, 1983
Acrylic and mixed media on canvas,
84 x 84 (213.4 x 213.4)
Gift of Douglas S. Cramer 84.23

Thomas Hart Benton (1889–1975)
Poker Night (from "A Streetcar Named Desire"), 1948
Tempera and oil on panel, 36 x 48 (91.4 x 121.9)
Mrs. Percy Uris Bequest 85.49.2

Ross Bleckner (b. 1949)
Count No Count, 1989
Oil and wax on canvas, 108 x 72⅛
(274.3 x 183.2)
Purchase, with funds from the Painting
and Sculpture Committee 89.28

John Currin (b. 1962)
Skinny Woman, 1992
Oil on canvas, 50⅛ x 38¹⁄₁₆ (127.3 x 96.7)
Purchase, with funds from The List
Purchase Fund and the Painting and
Sculpture Committee 92.30

Willem de Kooning (1904–1997)
Woman and Bicycle, 1952–53
Oil on canvas, 76½ x 49 (194.3 x 124.5)
Purchase 55.35

Guy Pène du Bois (1884–1958)
Mother and Daughter, 1928
Oil on canvas, 21¾ x 18 (55.2 x 45.7)
Purchase 31.183

Father and Son, 1929
Oil on canvas, 21½ x 18 (54.6 x 45.7)
Purchase 31.179

Philip Evergood (1901–1973)
The Jester, 1950
Oil on canvas, 72 x 96 (182.9 x 243.8)
Gift of Sol Brody 64.36

Eric Fischl (b. 1948)
A Visit To / A Visit From / The Island, 1983
Oil on canvas, 84 x 168 (213.4 x 426.7) overall
Purchase, with funds from the Louis and
Bessie Adler Foundation, Inc., Seymour M.
Klein, President 83.17a–b

Leon Golub (b. 1922)
White Squad I, 1982
Synthetic polymer on canvas, 120 x 184
(304.8 x 467.4)
Gift of the Eli Broad Family Foundation and
purchase, with funds from the Painting
and Sculpture Committee 94.67

Stephen Greene (b. 1918)
The Burial, 1947
Oil on canvas, 42 x 55 (106.7 x 139.7)
Purchase 49.16

Philip Guston (1913–1980)
Cabal, 1977
Oil on canvas, 68 x 116 (172.7 x 294.6)
50th Anniversary Gift of Mr. and Mrs.
Raymond J. Learsy 81.38

Edward Hopper (1882–1967)
Soir Bleu, 1914
Oil on canvas, 36 x 72 (91.4 x 182.9)
Josephine N. Hopper Bequest 70.1208

Alex Katz (b. 1927)
The Red Smile, 1963
Oil on canvas, 78¾ x 114¾ (200 x 291.5)
Purchase, with funds from the Painting
and Sculpture Committee 83.3

Jack Levine (b. 1915)
Gangster Funeral, 1952–53
Oil on canvas, 63 x 72 (160 x 182.9)
Purchase 53.42

Ed Paschke (b. 1939)
Violencia, 1980
Oil on canvas, 74 x 96 (188 x 243.8)
Gift of Sherry and Alan Koppel in memory
of Miriam and Herbert Koppel 82.46

Andres Serrano (b. 1950)
Klansman (Knight Hawk of GA of the Invisible Empire V), 1990, from the
portfolio **The Artist Space Portfolio**
Cibachrome and plexiglass, 29¹⁵⁄₁₆ x 23½
(76 x 59.7)
Gift of Joanne Leonhardt Cassullo and
The Dorothea L. Leonhardt Foundation,
Inc. 94.203

Cindy Sherman (b. 1954)
Untitled #146, 1985
Cibachrome print, 71⁹⁄₁₆ x 48⅛ (181.8 x 122.2)
Purchase, with funds from Eli and Edythe
L. Broad 87.49

Kiki Smith (b. 1954)
Untitled, 1990
Beeswax and microcrystalline wax figures
on metal stands: female figure,
64½ x 17⅜ x 15¼ (163.8 x 44.1 x 38.7),
without base; male figure, 69⁷⁄₁₆ x 20½ x 17
(176.4 x 52.1 x 43.2), without base
Purchase, with funds from the Painting
and Sculpture Committee 91.13a–d

Andy Warhol (1925–1987)
Ethel Scull 36 Times, 1963
Synthetic polymer paint silkscreened on
canvas, 79¾ x 143¼ (202.6 x 363.9) overall
Gift of Ethel Redner Scull 86.61a–jj

Andrew Wyeth (b. 1917)
Winter Fields, 1942
Tempera on canvas, 17¼ x 41 (43.8 x 104.1)
Gift of Mr. and Mrs. Benno C. Schmidt in
memory of Mr. Josiah Marvel, first owner
of this picture 77.91

Section 5: The Object

Richard Artschwager (b. 1923)
Description of Table, 1964
Formica on wood, 26⅛ x 31⅞ x 31⅞
(66.4 x 81 x 81)
Gift of the Howard and Jean Lipman
Foundation, Inc. 66.48

Jim Dine (b. 1935)
A Black Shovel, Number 2, 1962
Oil and shovel on canvas, 36 x 84½
(91.4 x 214.6)
Gift of Dr. and Mrs. Bernard Brodsky 67.63

Marsden Hartley (1877–1943)
Painting, Number 5, 1914–15
Oil on canvas, 39½ x 31¾ (100.3 x 80.6)
Gift of an anonymous donor 58.65

Neil Jenney (b. 1945)
Saw and Sawed, 1969
Oil on canvas, 58½ x 70⅜ (148.6 x 178.8)
Gift of Philip Johnson 77.65

Jasper Johns (b. 1930)
White Target, 1957
Wax and oil on canvas, 30 x 30 (76.2 x 76.2)
Purchase 71.211

Donald Judd (1928–1994)
Untitled, 1968
Stainless steel and plexiglass, 33 x 68 x 48
(83.8 x 172.7 x 121.9)
Purchase, with funds from the Howard and
Jean Lipman Foundation, Inc. 68.36

Sol LeWitt (b. 1928)
A six inch (15cm) grid covering each of the four black walls. White lines to points on the grids. 1st wall: 24 lines from the center; 2nd wall: 12 lines from the midpoint of each of the sides; 3rd wall: 12 lines from each corner; 4th wall: 24 lines from the center, 12 lines from the midpoint of each of the sides, 12 lines from each corner, 1976
Crayon lines and graphite grid on walls, dimensions variable
Purchase, with funds from the Gilman Foundation, Inc. 78.1.1–4

Sherrie Levine (b. 1947)
Untitled (Golden Knots: 1), 1987
Oil on plywood under plexiglass,
62⅝ x 50⁹⁄₁₆ x 3½ (159.1 x 128.4 x 8.9) overall
Purchase, with funds from the Painting and Sculpture Committee 88.48a-b

John McCracken (b. 1934)
Violet Block in Two Parts, 1966
Plywood, fiberglass, and lacquer, two parts, 24 x 36 x 45 (61 x 91.4 x 114.3) overall
Purchase, with funds from the Howard and Jean Lipman Foundation, Inc. 66.92

Gerald Murphy (1888–1964)
Cocktail, 1927
Oil on canvas, 29¹⁄₁₆ x 29⅞ (73.8 x 75.9)
Purchase, with funds from Evelyn and Leonard A. Lauder, Thomas H. Lee, and the Modern Painting and Sculpture Committee 95.188

Bruce Nauman (b. 1941)
Six Inches of My Knee Extended to Six Feet, 1967
Fiberglass, 68½ x 5¾ x 3⅞ (174 x 14.6 x 9.8)
Partial and promised gift of Robert A.M. Stern P.14.91

Claes Oldenburg (b. 1929)
Shirt, 1960
Painted plaster, muslin, and wire,
30¹⁵⁄₁₆ x 24½ x 4¾ (78.6 x 62.2 x 12.1)
Gift of Andy Warhol 75.54

The Black Girdle, 1961
Painted plaster, muslin, and wire,
46½ x 40 x 4 (118.1 x 101.6 x 10.2)
Gift of Howard and Jean Lipman 84.60.2

Braselette, 1961
Painted plaster, muslin, and wire,
41 x 30¼ x 4 (104.1 x 76.8 x 10.2) overall
Gift of Howard and Jean Lipman 91.34.5

Morton Schamberg (1881–1918)
Untitled (Mechanical Abstraction), 1916
Oil on composition board, 20 x 16 (50.8 x 40.6)
50th Anniversary Gift of Mrs. Jean Whitehill 86.5.2

Frank Stella (b. 1936)
Die Fahne Hoch, 1959
Enamel on canvas, 121½ x 73 (308.6 x 185.4)
Gift of Mr. and Mrs. Eugene M. Schwartz and purchase, with funds from the John I.H. Baur Purchase Fund; the Charles and Anita Blatt Fund; Peter M. Brant; B.H. Friedman; the Gilman Foundation, Inc.; Susan Morse Hilles; The Lauder Foundation; Frances and Sydney Lewis; the Albert A. List Fund; Philip Morris Incorporated; Sandra Payson; Mr. and Mrs. Albrecht Saalfield; Mrs. Percy Uris; Warner Communications Inc., and the National Endowment for the Arts 75.22

Andy Warhol (1925–1987)
Green Coca-Cola Bottles, 1962
Oil on canvas, 82½ x 57 (209.6 x 144.8)
Purchase, with funds from the Friends of the Whitney Museum of American Art 68.25

Jackie Winsor (b. 1941)
Cement Piece, 1976–77
Wire, cement, and wood, 36 x 36 x 36 (91.4 x 91.4 x 91.4)
Purchase, with funds from the Louis and Bessie Adler Foundation, Inc., Seymour M. Klein, President; Mr. and Mrs. Robert M. Meltzer; and Mrs. Nicholas Millhouse 80.7

Christopher Wool (b. 1955)
Untitled, 1990
Alkyd enamel on aluminum, 108 x 72 (274.3 x 182.9)
Purchase, with funds from the Painting and Sculpture Committee 91.2